IMAGES
of America

MISSOULA

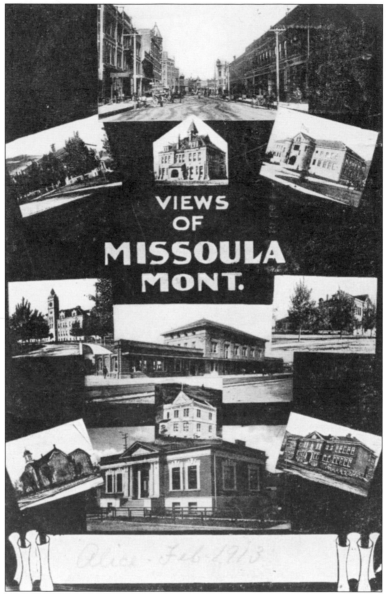

This postcard view from 1913 shows a street scene, the railroad station, the library, and buildings of the public schools and state university. (Courtesy of Frank Houde.)

ON THE COVER: C.P. "Cap" Higgins was one of Missoula's founders. He started the Missoula National Bank, but after losing his position as president, he started another bank, the Western Montana National Bank, in what is now called the Higgins Block, constructed in 1889. It is the most majestic building in the downtown area. Unfortunately, Higgins died in 1889 before the building was completed. The building, which initially included the D.J. Hennessy Mercantile Company as well, has the best Queen Anne–style commercial architecture in downtown. In 1911, an addition was added on the east end facing Main Street, and modifications have been made through the years. It now houses the Sterling Savings Bank and upstairs offices. (Courtesy of the author.)

IMAGES
of America

MISSOULA

Stan B. Cohen

ARCADIA
PUBLISHING

Published by Arcadia Publishing
Charleston, South Carolina

Printed in the United States of America

Library of Congress Control Number: 2012945311

For all general information, please contact Arcadia Publishing:
Telephone 843-853-2070
Fax 843-853-0044
E-mail sales@arcadiapublishing.com
For customer service and orders:
Toll-Free 1-888-313-2665

Visit us on the Internet at www.arcadiapublishing.com

*Dedicated to the photographers, either professional or amateur, who
left a legacy for Missoula citizens from before 1900 to the present*

CONTENTS

Acknowledgments 6

Introduction 7

1. Early Views 9

2. Fort Missoula 15

3. Disasters 23

4. Transportation 33

5. Schools and the University of Montana 47

6. US Forest Service 63

7. Street Scenes 71

8. Government, Churches, and Hospitals 79

9. Business and Industry 93

10. People, Places, and Things 111

Bibliography 126

Preserve Historic Missoula 127

ACKNOWLEDGMENTS

Photographs in this book were obtained from my personal collection, from the Montana Historical Society (MHS) in Helena, and from the K. Ross Toole Archives in the Maureen and Mike Mansfield Library at the University of Montana–Missoula (UM). My collection started more than 30 years ago, and I have found photographs from all over the country. I have used some of these photographs in two previous Arcadia publications—Then & Now and the Postcard History Series—and many of my own local publications, as I have been publishing books for 37 years. In addition, I have published other local historical photographic books.

I especially want to thank Pasty O'Keefe for doing the typing for me. Without her, my work to do this book would have been much harder to complete. Suzanne Julin wrote the mission statement for Preserve Historic Missoula, an active historical society on whose board I serve. Philip Maechling, Missoula's historic preservation officer, was very helpful with the historical facts and editing. Other people who helped with photographs for this particular book are Steve Bixby, Linda Lennox, Tex Johnson, John Rimel, Dennis Sain, Claudia Brown, Dean Hostad, Barbara Finn, Bill Taylor, Donna Hart, Sherry Lierman, Tom Mulvaney, Frank Houde and Dana Kopp of Providence St. Patrick Hospital. In addition, photographs were obtained from the Western Montana Fair, the Museum of Mountain Flying—both of which are in Missoula—and the US Forest Service. The historical photographs of Mark Twain in Missoula were provided by Kevin MacDonnell of Austin, Texas, through Elmira College and Mark Woodhouse, the College and Mark Twain Archivist at Gannett-Tripp Library, Elmira College in Elmira, New York.

I also made a concentrated effort to find new, previously unpublished photographs, including some from my own collection. Information for the captions came from my own local history books and many other local interest books that have been published through the years. See the bibliography for a listing.

Photograph captions with no acknowledgments are from my collection, the Montana Historical Society photographs are marked MHS with collection numbers when known, and photographs from the University of Montana Archives are marked UM with negative numbers when known, as required by both institutions. Other photographs are acknowledged to their source. There are a large number of dates and historical facts in the captions; any mistakes are my responsibility.

INTRODUCTION

This is my third book for Arcadia. My first was a pictorial book of Missoula using a massive postcard collection given to the Northern Rockies Heritage Center at Fort Missoula. The second was a Then & Now pictorial of Missoula, coauthored with Philip Maeching, Missoula's historic preservation officer.

In addition, in the past 36 years as an author and publisher, I have produced two pictorial books on Missoula's history as well as *The First Missoula County High School, The Western Montana Fair, The History of Smokejumpers, The Forest Fires in Montana and Yellowstone National Park in 1988, The Great Forest Fire in Montana and Idaho in 1910, A History of the United States Forest Service's Region One in Missoula, Downhill Skiing in Missoula, The University of Montana,* and many other books for other authors on different subjects in western Montana.

With this book, I made a major effort to find as many new, previously unpublished photographs and to not duplicate any photographs from my two other Arcadia publications about Missoula. I was surprised at the number of new photographs found, some even in my extensive collection. So this book should be a good complement to the first two publications.

Since its founding in 1860 as Hellgate Village, about four miles west of downtown Missoula, it has become the major city in western Montana and the second-largest and the oldest large city in the state.

This size is due in part to the fact that Missoula is at the heart of five valleys, with three major rivers—the Clark Fork of the Columbia, the Blackfoot, and the Bitterroot—bisecting or flowing through part of the city and Missoula County. With the destruction of the 1908 dam at Milltown, just east of Missoula, the Clark Fork and the Blackfoot Rivers flowed freely together for the first time in more than a century. Although the rivers were never used commercially—except for the Blackfoot for floating logs to the sawmills in Bonner and Milltown—they did provide the power to run the sawmills and the electrical supply for the city for many years.

In 1865, the founders of Missoula—C.P. Higgins, Frank Worden, and others—moved four miles east of Hellgate Village and built a mill on the Clark Fork using a diversion millrace of Rattlesnake Creek water to run it. From this mill, which produced lumber and grain and was ultimately torn down in 1912, the city expanded on the north side of the Clark Fork River, which cuts the present city in two. Streets and subdivisions were planted along the same route the Lewis and Clark expedition came through in 1806. In the 1860s, the Mullan Military Road, which became a major trading route from Fort Benton, Montana, to Walla Walla, Washington, passed through what became the Hellgate Village and the original town site of Missoula.

The town had about 400 people when the Northern Pacific Railroad reached Missoula in 1883, connecting the town to the east and west by rail. From this date, the downtown grew rapidly, with hotels and eating establishments constructed close to the depot at the end of Higgins Avenue. A little later, several hotels and large commercial buildings were built from the tracks south to the river.

The abundance of timber in the area and good railroad transportation caused a rapid development of the lumber industry, with many sawmills in town, large mills in Bonner along the Blackfoot River, several miles east of town, and other lumber-related industries around the county.

The University of Montana was established in 1893, and by 1897, it had its own campus on the south side of town. Today, the university has grown to include campuses in Dillon and Butte and offers vocational training in several cities.

The Chicago, Milwaukee, St. Paul & Pacific Railroad (also known as the Milwaukee Road) came to town in 1909, spurring growth on the south side. Although today the timber industry has largely gone, Missoula has become the commercial, medical, governmental, cultural, and recreation center for western Montana and even provides services for the Bitterroot Valley to the south and into Idaho.

The city boasts nine historic districts and an active historical segment, including the Fort Missoula Complex, the Northern Rockies Heritage Center, the Missoula City/County Preservation Office, and Preserve Historic Missoula; six active historical, art, and wildlife museums; the nation's largest smokejumper base; a major supply center for fighting forest fires; the largest aerial firefighting operation in the nation; and an international airport. There are also minor league baseball and football teams; two ice rinks; an active county fair; university athletics, providing year-around activities; many parks and trails; a major ski area 13 miles north of town; and a wilderness area bordering the city limits.

Missoula, known as the Garden City and the River City, has been written up in many magazines as one of the most livable cities in the nation. Preserve Historic Missoula, the sponsor of this book, is just one of the many organizations that have contributed to this wonderful part of the country.

One

EARLY VIEWS

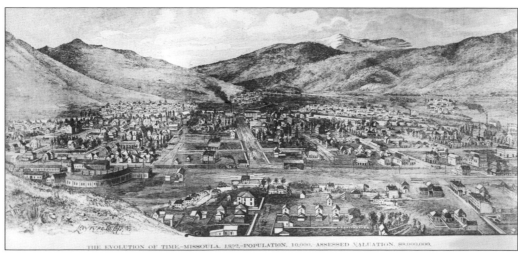

THE EVOLUTION OF TIME.—MISSOULA, 1892,—POPULATION, 10,000. ASSESSED VALUATION, $8,000,000.

This drawing of most of Missoula was published in the 1892 Missoula and Coeur d'Alene special edition of the *Missoula Gazette*. The population was around 3,500 at the time, with many people working in the lumber industry and on the railroad—the roundhouses seen at the extreme left. Higgins Avenue, the broad street in the center, leads to the bridge across the Clark Fork River.

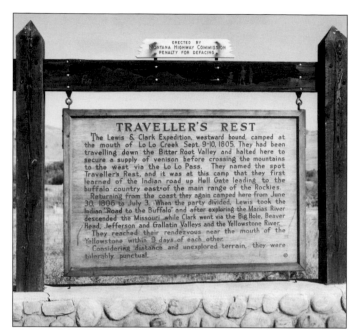

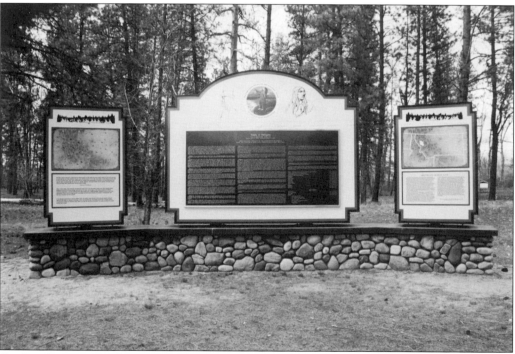

Travelers' Rest State Park, just outside of Lolo, south of Missoula, marks the location of a centuries-old Native American gathering ground lying at a hub of ancient travel and trade routes. Lewis and Clark's 33-member party camped here in September 1805 and again in late June 1806 on their 4,000-mile journey. Lewis called the nearby creek "Travellers Rest." In 2002, archeologists found evidence of the party's latrine and central fire here, making the park one of the few sites in the nation with physical confirmation of the group's visit. (Courtesy of US Forest Service.)

On October 4, 2003, this memorial was dedicated at Council Grove State Park, west of Missoula on Mullen Road. The memorial's three panels, designed and created under the leadership of the Confederated Salish and Kootenai Tribes, present the full text of the July 9, 1855, treaty that established the Flathead Reservation.

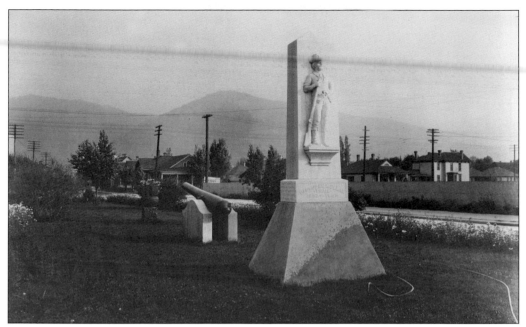

The Mullan Military Road was built from Fort Benton, Montana, to Walla Walla, Washington, in 1860. These monuments were donated along the road in 1916 by the president of the Northern Pacific Railway, Jule Murat Hannaford. This one was originally in front of the Missoula Northern Pacific depot but was later moved. Another was donated by William A. Clark and has been relocated to Milltown. (Courtesy of the Washington State Historical Society.)

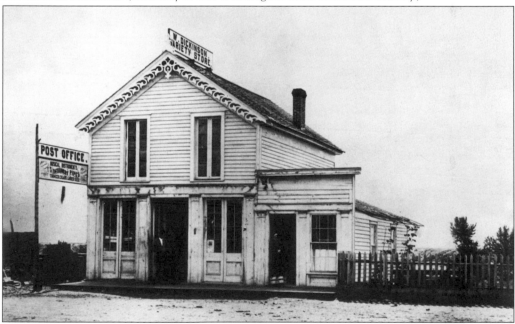

William H.H. Dickinson and his wife, Emma, who was Missoula's first schoolteacher, operated a variety store in the 100 block of East Front Street in the 1870s. It also served as the local post office for several years, with Dickinson as postmaster. Dickinson School is named after Emma Dickinson. (Courtesy of UM: 70-98.)

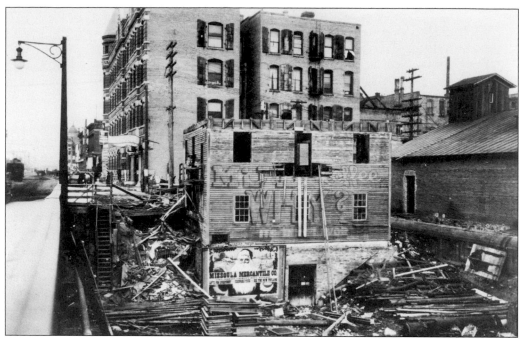

These two photographs were taken in 1912 and show the dismantling of the original mill, built in 1865–1866. C.P. Higgins and Frank Worden moved to this site, four miles east of the old Hellgate Village, to build a sawmill and gristmill for better water resources. Thus, Missoula Mills—the town's first name—began at this site. The town began to be built along the nearby Mullan Military Road. The mill eventually became a carpenter's shop, and a parking structure now occupies this site next to the First Interstate Bank. (Both courtesy of MHS: 949-420 and 949-421.)

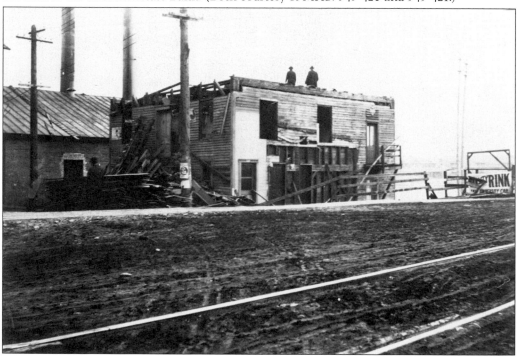

Frank Woody, one of the original founders of Missoula, is seen here in 1910 in front of the 1860 trading post that was part of the original Hellgate Village, about four miles west of present-day Missoula. Woody was prominent in early Missoula history and had a street named after him. (Courtesy of UM: 75-6013.)

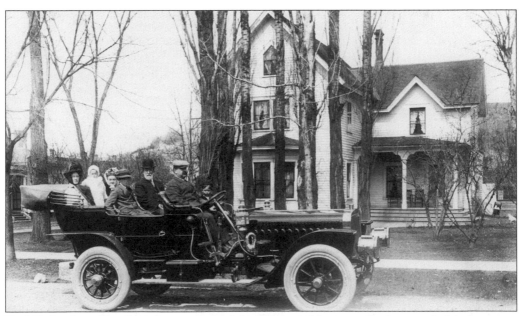

Fred T. Sterling (the driver), president of the Western Montana Bank, owned this fancy car around 1910. Frank Worden and family are in the back. In the background is the home, on East Pine Street, of Worden and his family, one of Missoula's pioneers. The home was built in 1874 and is the oldest standing house in Missoula and is now privately owned. (Courtesy of the Brad Morris family.)

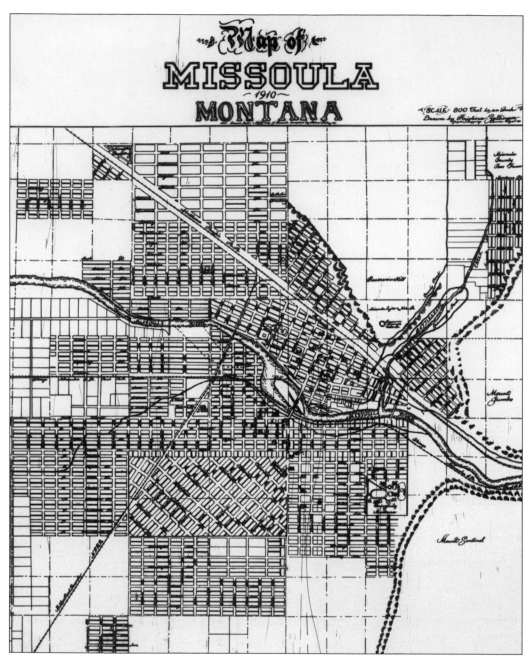

By 1910, when this map was drawn, the outline of the city of Missoula was well defined. The north-south grid has been established and the downtown area along with both railroad areas have been developed. The university, in the right bottom at the foot of Mount Sentinel was laid out in 1895. The Slant Street or South Missoula area is very visible and the Rattlesnake area has been platted and development started. Today, Missoula is the second-largest city in the state and subdivided areas cover much of the extensive Missoula Valley.

Two

FORT MISSOULA

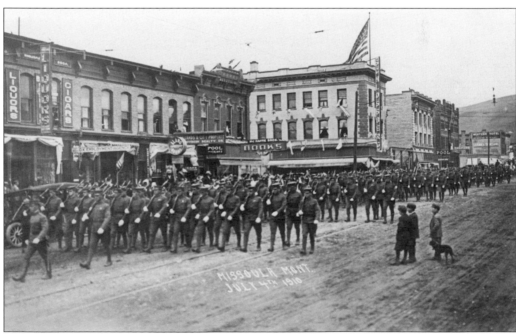

The 19th Infantry was stationed at Fort Missoula from March 20, 1910, to February 13, 1913. There were four companies of approximately 240 men. They returned again in October 1914 and left again in April 1915. The Mexican border war was occurring at the time, and it is likely that the 19th went on to Texas. Here, the troops are marching south on Higgins Avenue just past Broadway on the Fourth of July in 1910. (Courtesy of Tom Mulvaney.)

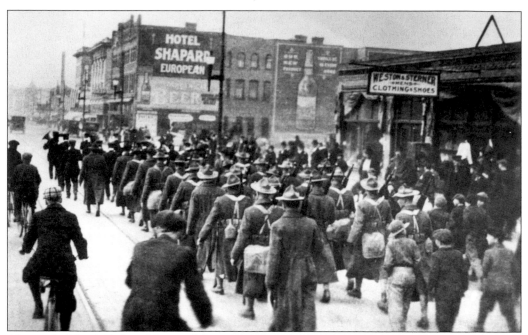

Above, the North Dakota National Guard marches down Higgins Avenue on April 4, 1917, from the Northern Pacific depot. The troops came to garrison Fort Missoula just before the United States entered World War I. The Weston-Sterner Men's Clothing and Shoes building stayed in this type of business for many years under different names. The Hotel Shapard burned down on January 1, 1942. The photograph below was taken four days later on Easter Sunday, April 8, 1917, and shows a patriotic demonstration after the declaration of war, in front of the old Hammond Building on Higgins Avenue. (Both courtesy of Barbara Finn.)

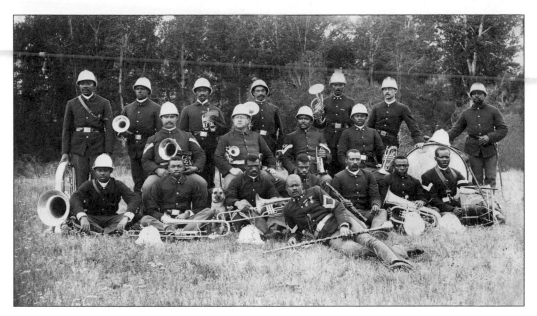

In the 1890s, Fort Missoula was garrisoned by the 25th Infantry, which was made up of four companies of black soldiers with white officers. Col. Andrew S. Burt was the commanding officer. Theophilus Gould Steward of the 25th was one of a few or possibly the only black chaplain in the US Army. By this time, there was a large migration to the west and most of the Indian conflicts were over, so the regular Army troops, mainly black—sometimes called "buffalo soldiers"—were used to garrison the western forts. The 25th Infantry was the first regular Army unit called up for the Spanish-American War. They marched out of Fort Missoula in April 1898. In the photograph above of the band, note the one white musician. Below, soldiers pose near the rock formations at Lolo Hot Springs. (Both courtesy of UM, Elrod Collection: B.I. J-3 and J-4.)

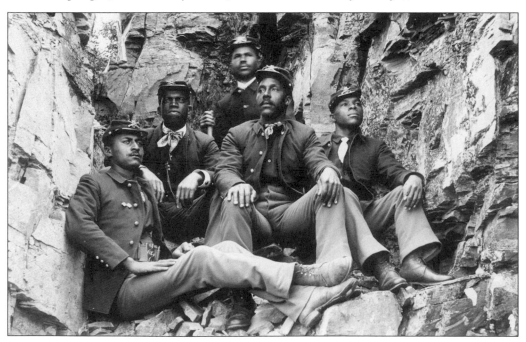

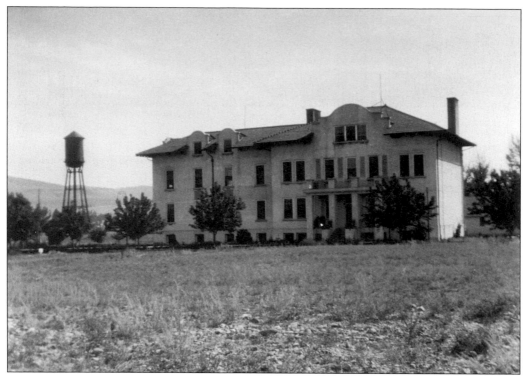

The post hospital was built between 1910 and 1912, when many of the preserved buildings on this end of the fort property were built. The water tower was constructed in 1912 to supply water to the buildings at the fort. The hospital is now the Western Montana Mental Health Center and the water tower is now owned by the Northern Rockies Heritage Center. (Courtesy of John Moe.)

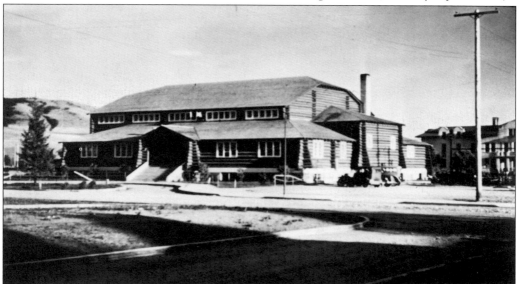

This impressive log structure was constructed by the Works Progress Administration and the Civilian Conservation Corps in 1939 and opened in 1940. It was across the street from the post headquarters (now Heritage Hall). The air-conditioned building had a boxing ring, a bowling alley, a basketball court, a kitchen, a bar, and other sports facilities. It burned down on December 7, 1946.

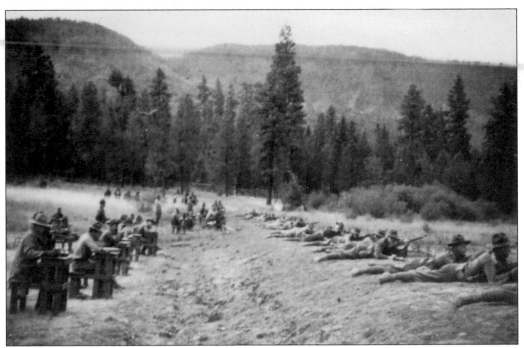

When Fort Missoula was established in 1877, the US Army set aside a 1,600-acre timber reserve at the top of Pattee Canyon for the harvesting of trees for building construction. This area has now been incorporated into a Lolo National Forest recreation area. When the Army garrisoned the fort, it needed a firing range, so it first went out to the target-range area near the fort. Later, in the 1930s, the Army moved up to the Pattee Canyon area and established the range seen in both these images, which was used for many years. Remnants of the range can still be found today. (Both courtesy of Tex Johnson.)

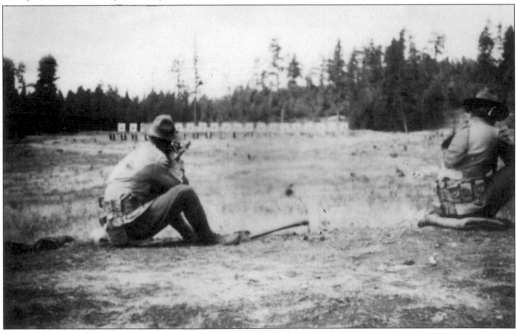

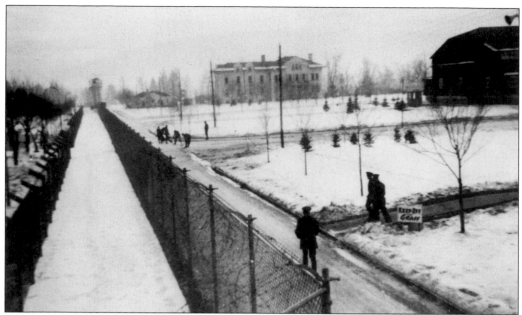

Toward the end of World War II, part of Fort Missoula was turned into an Army prison, mainly for serious crimes. The Italian and Japanese detainees had left by this time. Some of the buildings still standing were taken over by the University of Montana when the prison closed in 1946. The photograph above shows a winter scene with the fort hospital in the background and the recreation hall to the right. Notice the sign warning "Keep Off the Grass." Below is a summer view in 1945, with the prisoners marching on the parade ground. Prisoners convicted of minor crimes, such as going AWOL, had a choice of reenlisting or receiving a dishonorable discharge. Many chose discharge, and some even escaped. (Both courtesy of John Moe.)

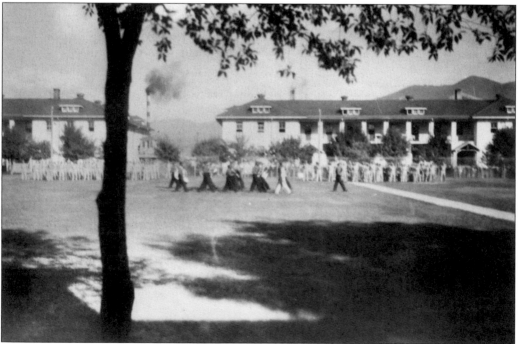

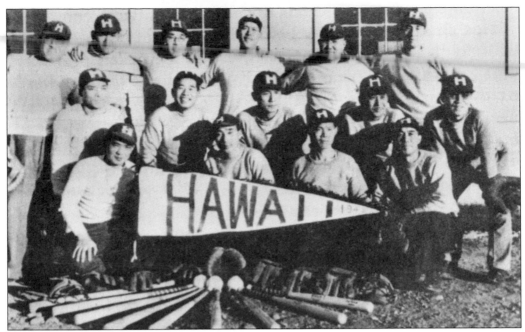

More than 1,000 Japanese American men were sent to the fort in December 1941 as part of the US government's program to move all prominent Japanese Americans and aliens from the West Coast to interior sites. They did not mix with the interned Italian seamen. The Japanese detainees worked in the area's sugar beet fields and truck farms. By the summer of 1942, most of the Japanese detainees were sent to the other detention camps in the country. The detainees seen here were brought to the fort from Hawaii.

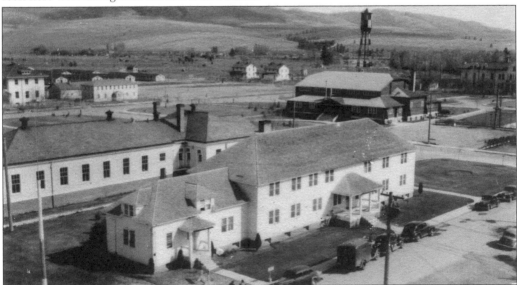

Building T-1 at Fort Missoula was located next to the site of the original chapel in 1939. It was post headquarters in the 1940s for the Immigration and Naturalization Service of the Justice Department, and trials and inquiries were held in the upstairs courtroom for the Japanese detainees. After the war, it was used by the US Forest Service and other government offices until it was sold to the county museum in 2009. The historic courtroom has been restored. (Courtesy of John Moe.)

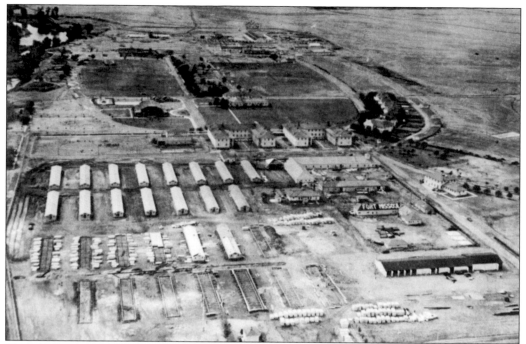

This photograph shows an overview of most of the fort reservation in the early 1940s. Notice that at this time, the surrounding area was not built up, as the fort was initially placed far from central Missoula in 1877. By 1922, close to 1,000 Italian seamen were brought to the fort from Italian ships on the East Coast to keep them from being scuttled. Barracks for them are being constructed in this photograph. Other buildings date from the 1870s to 1939.

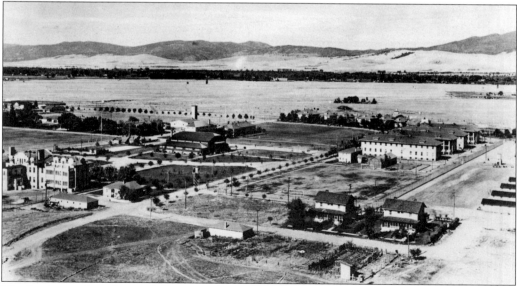

The fort is seen here from a different angle in 1941. The two U-shaped buildings and the adjacent officers' row, along with other buildings, were built between 1910 and 1912. Today, the fort has been parceled out to many different organizations, including a hospital complex, research buildings for the University of Montana, US Forest Service offices, two museums, other government offices, and the Northern Rockies Heritage Center. There is no longer a military presence at Fort Missoula.

Three

DISASTERS

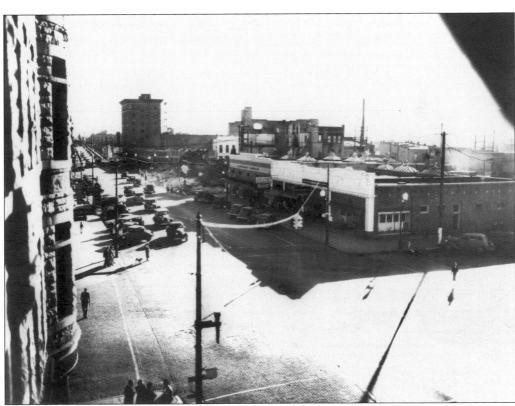

This photograph, looking south on Higgins Avenue, was probably taken on the second day after the disastrous fire that destroyed the Florence Hotel on September 24, 1936. Some whiffs of smoke can still be seen from the debris and the back of the building is still standing. The hotel was the social center of downtown Missoula. Several other stores on the first floor were destroyed, with a total loss of $400,000.

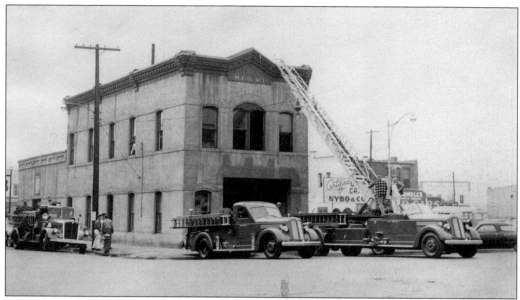

Missoula's first city hall, seen here in the 1950s, was constructed in 1887 at the corner of Main and Ryman Streets. It was also the city fire station, serving first as a volunteer unit in 1877 and becoming a paid department in 1911. In 1912, the city government moved out and the building served as the main fire station until 1954. The building was demolished in 1966 to make room for the Central Square building.

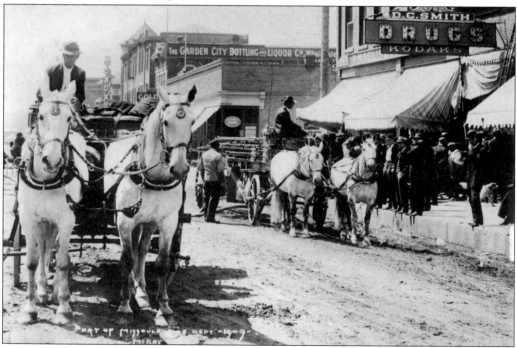

The Missoula Fire Department was all horse-drawn in this 1909 photograph, taken at the corner of present Higgins Avenue and Broadway. The D.C. Smith Drugs building dates from 1890 and was one of the oldest drugstores in the city. It went out of business years ago, but the building has been restored and has housed several different businesses.

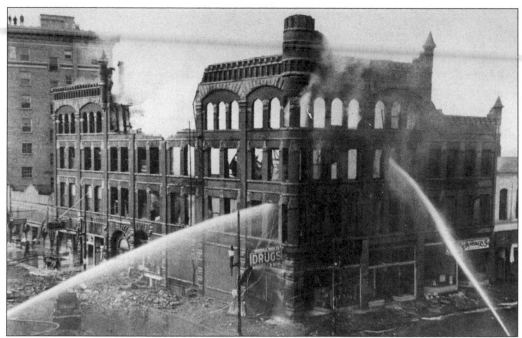

Prominent local businessman Andrew Benoni "A.B." Hammond built this imposing structure in the 1890s at the corner of Higgins Avenue and Front Street. It housed various businesses, including the old Missoula Drug Co. On October 9, 1932, the building was destroyed by fire. Two years later, the present Hammond Arcade was built, but only one floor was constructed due to the financial conditions of the Great Depression.

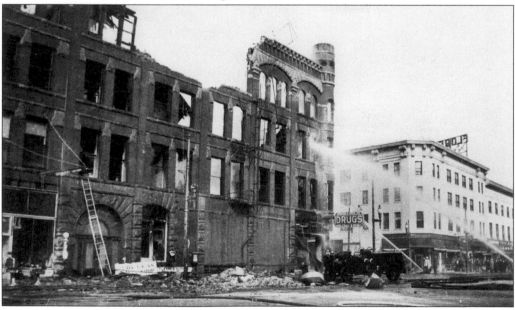

In this photograph, the remains of the Hammond Building are still smoldering from the October 9 fire. This was just one of many large building fires in the downtown area through the years. The 1913 Florence Hotel is across the street; four years later, it would become a fire casualty as well. Note the old fire truck below the drug sign.

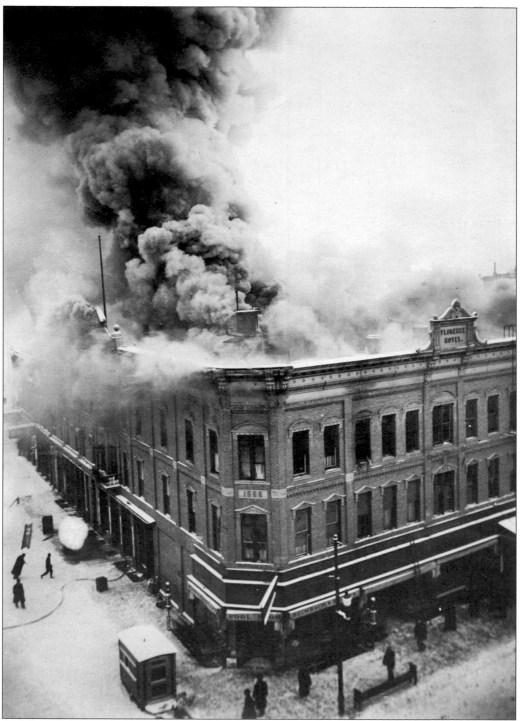

The first Florence Hotel was built in 1888 at the northwest corner of Higgins Avenue and Front Street. It was owned by A.B. Hammond and was the social center of the city. It was named for Hammond's wife, Florence. It even had its own horse-drawn stagecoach in the early 1900s. On January 13, 1913, a fire completely destroyed the fine old building.

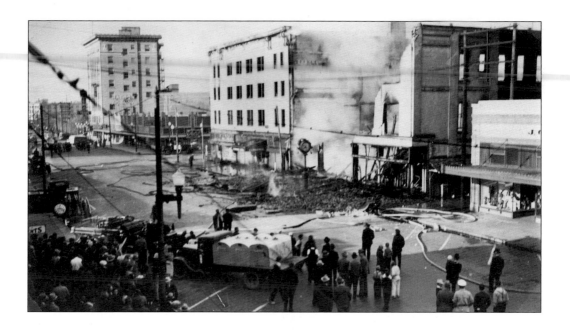

The second Florence Hotel, built in 1913, caught fire on September 24, 1936. Besides the hotel, several businesses on the street level were also destroyed. Losses were estimated at more than $400,000. The photograph above was taken on Higgins Avenue with the Wilma Theater in the background. A sidewalk clock had been at the location in front of Kohn Jewelers since 1918. In 1989, it was restored and still stands in the same approximate location. The photograph below was taken from the Front Street side. The fire totally destroyed the building, and the site stood empty for a few years until the present Florence Building was opened in 1941.

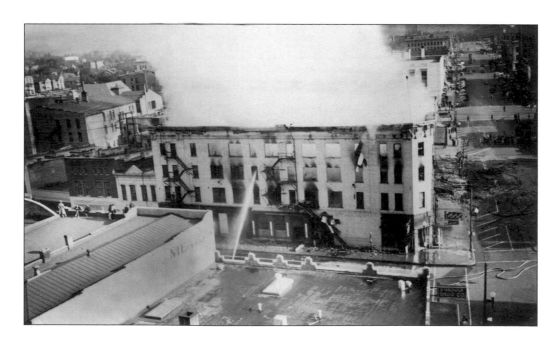

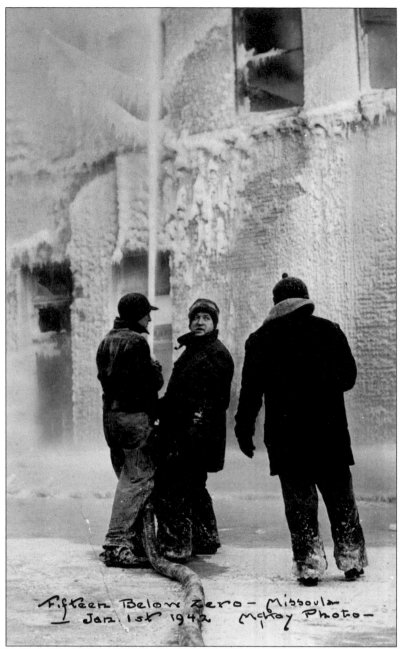

Fifteen Below Zero - Missoula
Jan. 1st 1942 McKay Photo-

Through the years, there have been many large and small fires in downtown Missoula. One of the costliest fires occurred on January 1, 1942, when the Ross Block and the Shapard Hotel burned down. The Ross Block housed the popular men's store Yandt's on the ground floor and a US army recruiting office on the second and third floors. The Greenhood Block, built in 1909, housed the Shapard Hotel, the Schramon-Heband meat market, and the Gamble store. During the fire, the temperature reached 15 degrees below zero and never got above freezing during the day, which impeded firefighting efforts. The total damage was placed at $350,000. The corner structure was rebuilt, and Yandt's reopened and continued in operation for many years. The hotel was never rebuilt. A restaurant now occupies the Yandt's location.

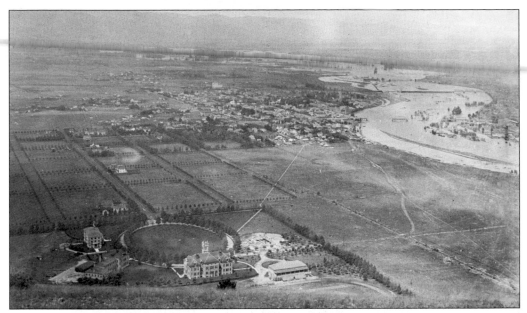

The Great Flood of 1908 occurred in June after 33 days of continuous rain, warm weather, and heavy runoff from the previous winter's snows. May 1908 was the wettest month in more than 28 years. The photograph above shows the extent of the flood in the downtown area, with the Higgins Avenue Bridge spans down. The extent of the flood on the south side and by the university can be seen. The Rattlesnake Valley was also hit hard. The photograph below shows the Orr House washed off its foundations and floating down Rattlesnake Creek. Missoula has not experienced a flood of this magnitude since.

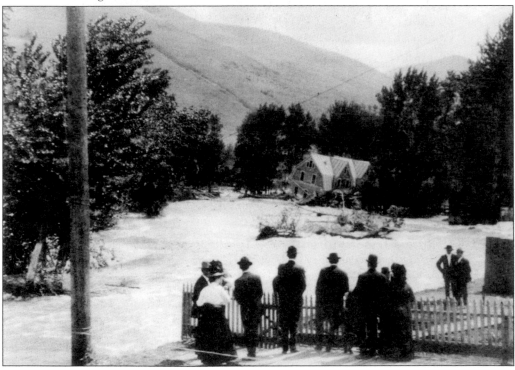

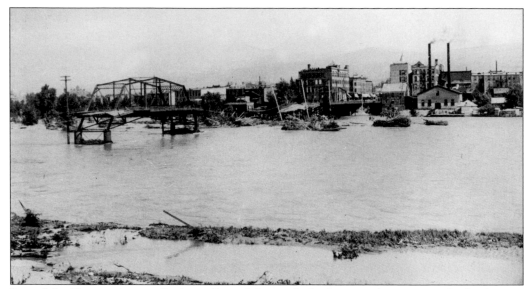

Part of the Higgins Avenue Bridge collapsed due to the high water. A temporary footbridge was constructed from both ends of the washed-out bridge so that people could get back and forth across the river. It became known as the "bounding bridge" because of its swaying nature. The downed bridge proved to be very inconvenient for construction projects on the south side if material had to come in on the Northern Pacific Railroad at the north end of Higgins Avenue. There was also a siding for the Milwaukee Railroad on Fourth Street on the south side.

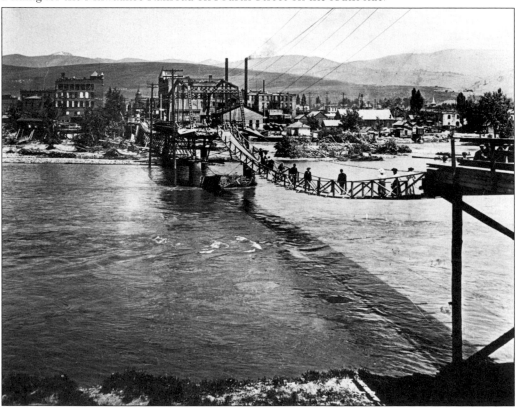

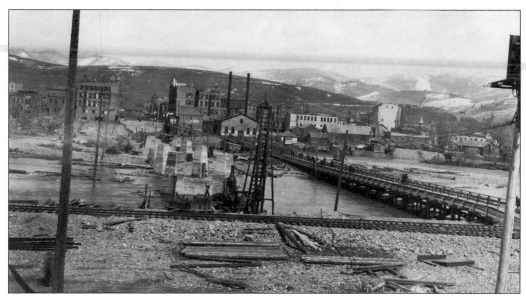

In October 1908, a temporary bridge was constructed just to the east of the washed-out bridge. This view, taken in early 1909, shows the footings for a new steel bridge, which opened that year. This bridge lasted until the present bridge was built in 1962. (Courtesy of MHS: 949-414.)

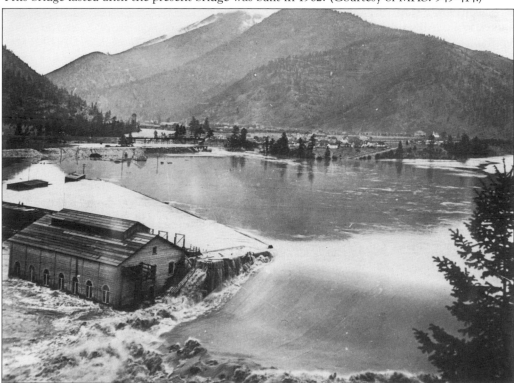

On Saturday, June 6, 1908, floodwaters impeded the Milltown Dam's ability to produce power, and part of Missoula was thrown into darkness. A city fire engine was stationed just outside the power plant to pump water from the machinery pit. There was some concern that the dam would not hold; though water ran over the top of the dam, it began to recede before the dam gave way.

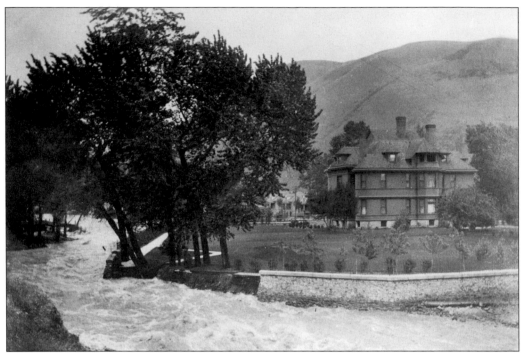

Rattlesnake Creek is one of the main drainages in Missoula. The high water washed away the retaining wall near the grove of trees protecting the Greenough Mansion (above), which was designed by Albert John "A.J." Gibson in 1894 for Thomas Greenough, an investor in lumber and mining interests. In 1965, the Greenough Mansion was cut in three sections and moved up to the Farviews subdivision to make room for the construction of Interstate 90. The mansion burned down in 1992 (below). (Both courtesy of Sherry Lierman.)

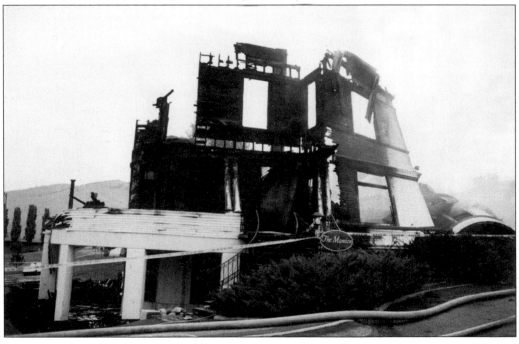

Four

TRANSPORTATION

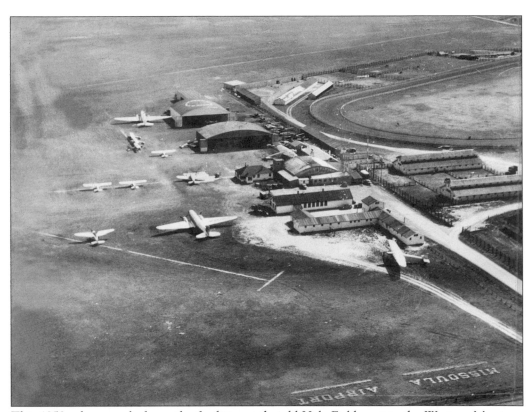

This 1950s photograph shows the facilities at the old Hale Field next to the Western Montana Fairgrounds. Most of the aviation buildings were used by Johnson Flying Service (JFS) and the US Forest Service's smokejumper program. JFS had many different aircraft in its 50-plus-year history, including (seen here) the DC-3, the Ford trimotor, the J-3 Cub, and TBMs, among others. The two horse barns at the fairgrounds (right) burned down on August 24, 1967.

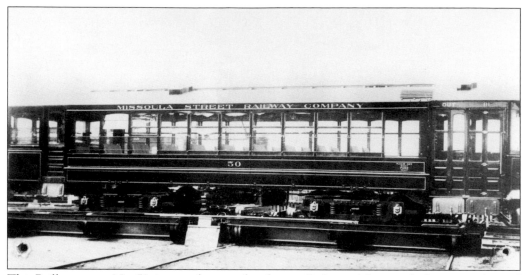

This Brill streetcar, No. 50, is seen above at the plant in St. Louis, Missouri, before it was shipped to Missoula. The Missoula Street Railway Company was started in 1910 by William A. Clark of Butte, one of the Butte "Copper Kings" and a US senator from Montana. This car ran from Bonner to Fort Missoula and was retired when city bus service started in 1932. Streetcar No. 50 ended up as a backyard tool shed and was donated to the Historical Museum at Fort Missoula in 1974. After some minor restoration work, enough funds were finally raised by 1996 to do a full restoration. After 16 years, the car was returned to its own building on the museum grounds in August 2012. The photograph below shows Streetcar No. 50 when it derailed east of Missoula. (Above, courtesy of PHPC; below, courtesy of Barbara Finn.)

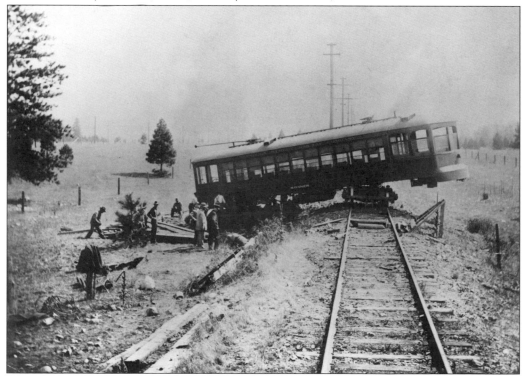

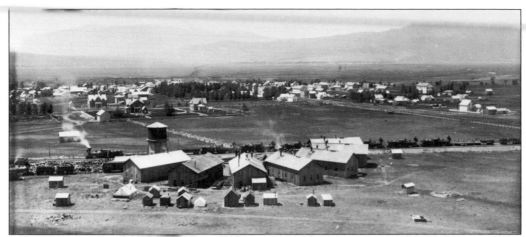

The Northern Pacific Railroad reached Missoula in 1883. A fleet of wood-burning locomotives was brought to Missoula to help power the first trains to cross mountainous western Montana. The tracks were completed to town on June 23, 1883, changing Missoula from a small supply center to a major transportation hub. Seven wooden locomotive sheds were built first and were later replaced by a brick roundhouse. (Courtesy of MHS: H-1327.)

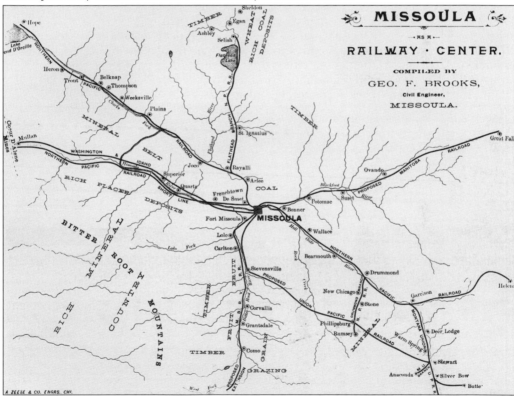

This 1880s map was compiled by George F. Brooks, who was prominent in Missoula real estate and insurance. Brooks Street, which is part of Highway 93 south, is named after him. Brooks laid out most of Missoula's south-side additions in his capacity as the county surveyor. In the 1880s, only the Northern Pacific Railroad and its branches were built. In 1987, Montana Rail Link bought the rail lines through Missoula. (Courtesy of UM: 81-401.)

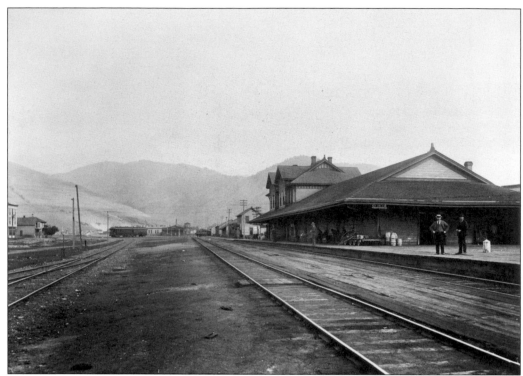

The Northern Pacific depot (above) was constructed in 1889 and served both passengers and freight until the present depot (below) opened in 1901, just to the west. The last remnants of the original building moved in 1948 to make way for the NP transport warehouse on Railroad Street. When the railroad reached Missoula, many hotels and eating establishments were built to take care of the passengers stopping in town. (Above, courtesy of MHS: H-1080; below, courtesy of Pictorial Histories Publishing Company.)

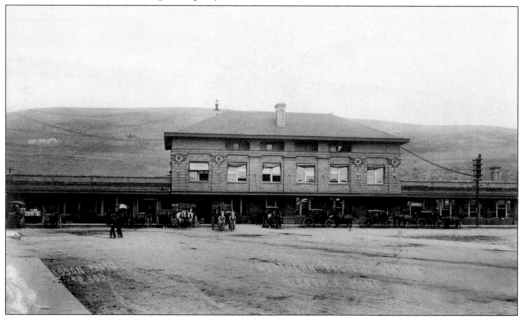

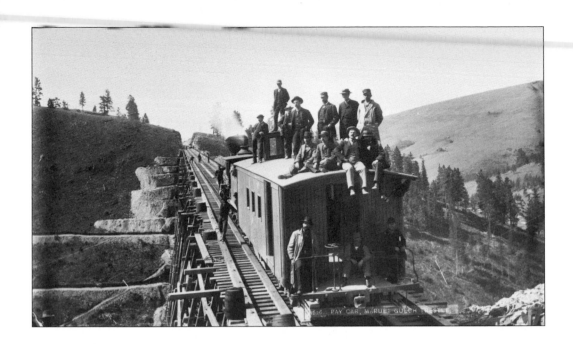

One of the largest construction projects for the new Northern Pacific Railroad was building the Marent trestle at the lower end of Evaro Canyon. A huge wooden trestle 226 feet high and 668 feet long was constructed in June 1883. At the time, it was the highest wooden railroad bridge in the world. Two years later, the wooden trestle was replaced by a steel structure. In 1945, the structure was further improved. The photograph above was taken by Northern Pacific photographer F. Jay Haynes in 1894. The photograph below, also taken by Haynes in 1883, shows a pay car for the workers who built the trestle. (Both courtesy of MHS: H-106B and H-1080.)

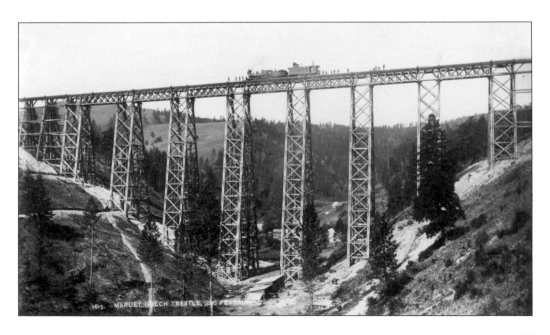

These two views show the construction of the last brick roundhouse on September 5, 1923. Ground-breaking for the first brick roundhouse and the machine shop began in May 1885 on the north side of Missoula, just off from the downtown area. This took the place of the seven wooden locomotive sheds built in 1883, when the railroad reached Missoula. Half of the brick roundhouse was demolished in 1960, the last half in 1986. Today, the locomotive turntable is still visible but the large area is empty of buildings. The photograph above, looking south, shows the present depot with the Missoula County Courthouse in the background. The photograph below looks east.

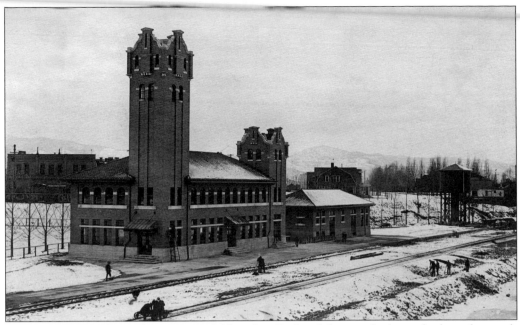

This photograph shows the new 1910 Milwaukee Railroad depot, which was built at the south end of the Higgins Street Bridge. The freight house is just to the right. A water tower is also to the right. The railroad was electrified in 1916 and converted to diesel in 1974 before going out of business in 1980. The structure has distinctive Romanesque arched windows and Spanish and other European design influences. In 1992, the station was purchased by the Boone and Crockett Club for its national headquarters. It also houses the University of Montana O'Connor Center for the Rocky Mountain West.

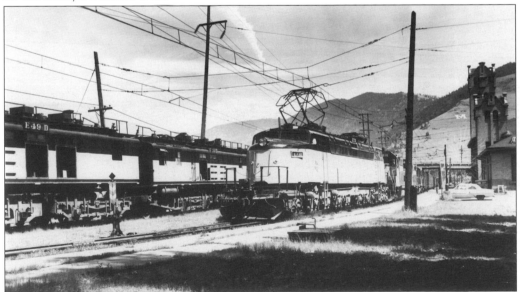

A Milwaukee Railroad "Little Joe" General Electric 3,300-volt locomotive E73 is seen here at the Missoula station in June 1969. The engines were originally built for the five-foot-gauge Trans-Siberian Railway in Russia. One of these engines is now on display at the Powell County Museum complex in Deer Lodge. (Courtesy of UM: 92-3404.)

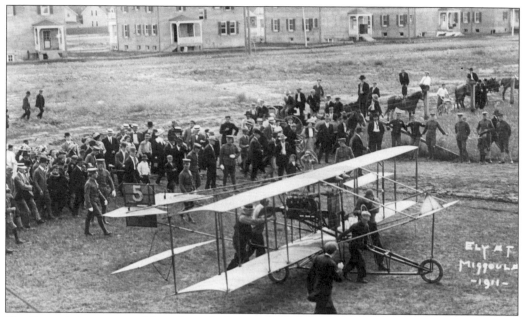

The first aviation event in Missoula took place on June 6, 1911, when noted aviator Eugene Ely took off from the ballpark at Fort Missoula in his Curtiss Pusher biplane. A sizable crowd came from all over the region to watch as Ely circled the Missoula Valley. Ely was also the father of naval aviation; he was the first to take off and land on a naval ship in 1911. (Courtesy of UM: 92-244.)

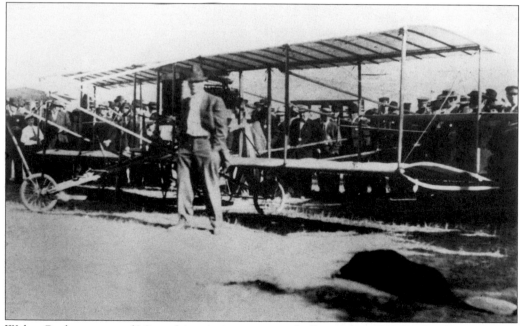

Walter Beck was one of Missoula's aviation pioneers. In September 1913, Beck, who was a gas-buggy racer and a self-taught pilot, flew his Curtiss pusher airplane from Bonner through Hellgate Canyon to Missoula. Beck helped with establishing Hale Field by securing a 60-day option on the proposed first airport in town. He died in Long Beach, California, in 1949.

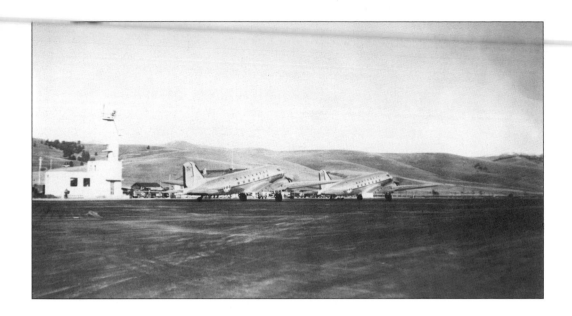

In 1939, a total of 1,300 acres of farmland six miles west of Missoula along Highway 10 was purchased with Works Project Administration and mill levy money to build an airport, which opened in June 1941. With paved runways and other improvements, it allowed Northwest Airlines, which started service to Missoula in 1934, to move to the new site. In 1954, all air operations were moved from Hale Field to the new airport when Hale was closed to build Sentinel High School on the site. Today, Johnson-Bell Field, or Missoula International Airport, is serviced by four airlines. Also based at the airport are two flight base operations, the US Forest Service fire depot, the Museum of Mountain Flying, Neptune Aviation, other flight facilities, and general aviation. Many improvements have been made through the years, including a new state-of-the-art flight tower. (Both courtesy of the Museum of Mountain Flying.)

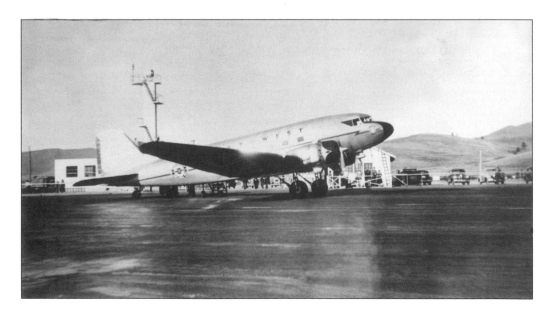

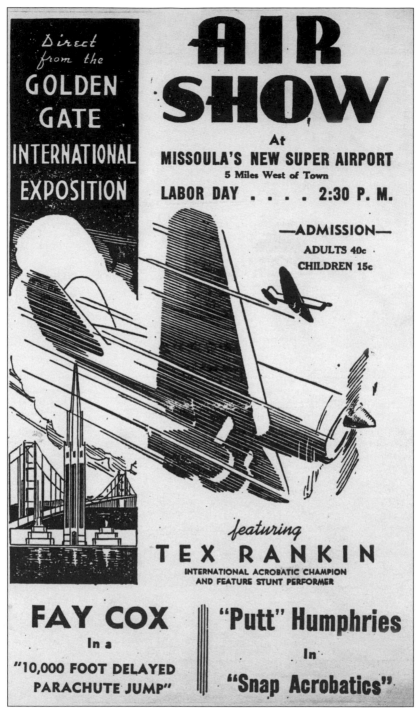

The first air show at the present airport, Johnson-Bell Field, was held in September 1939, not long after the facility opened. Tex Rankin was a pilot in World War I. He served as a flight instructor for many years and was also a well-known stunt pilot. He later started the Civilian Pilot Training Program in California, turning out 10,000 air cadets, including some of America's leading fighter aces during the war.

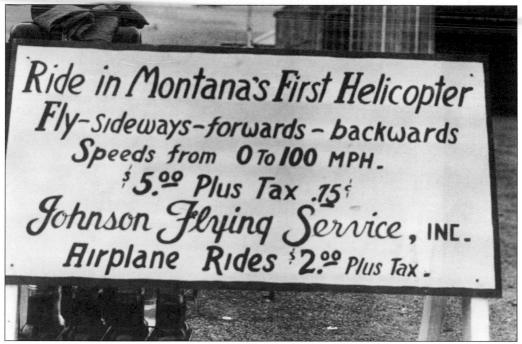

Johnson Flying Service brought the first helicopter to Montana in 1948. It was a Bell 47, made by the Bell Helicopter Company. The helicopter was used for years for a variety of purposes. It carried two people and was also used as a commercial attraction (above). The photograph below was taken at the old Dornblazer Field on the University of Montana campus. Jack Hughes was the first helicopter pilot in Montana.

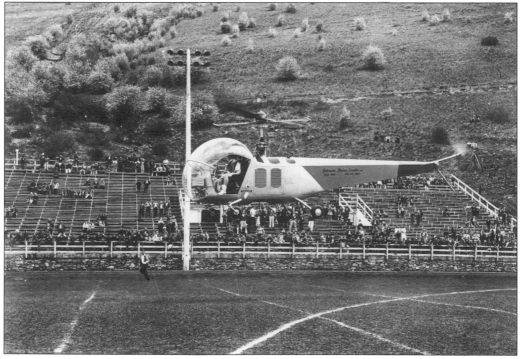

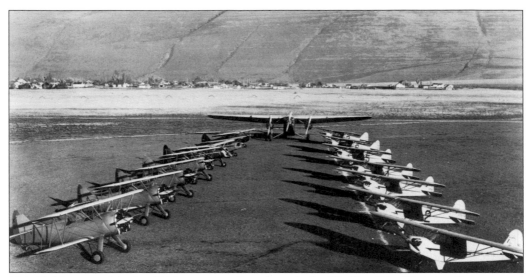

Hale Field was used in the 1940s to train pilots through the Civilian Pilot Training Program and during World War II for primary training for Air Force cadets. This 1940 photograph shows a Ford trimotor at the top with a row of Stearman aircraft on the left and a row of J-3 Cubs on the right. Hundreds of potential pilots went through this program in this five-year period. (Courtesy of Robert Jones.)

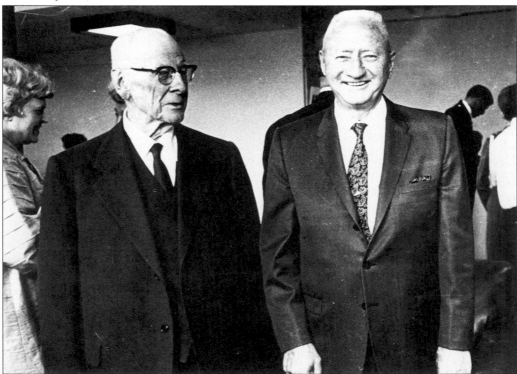

The two men most responsible for getting the present airport built were Harry Oscar "H.O." Bell (left) and Bob Johnson. Bell was a local Ford dealer and aviation enthusiast and Bob Johnson was a local aviation pioneer. The airport is named Johnson-Bell Field, although now it is also called Missoula County Airport or Missoula International Airport.

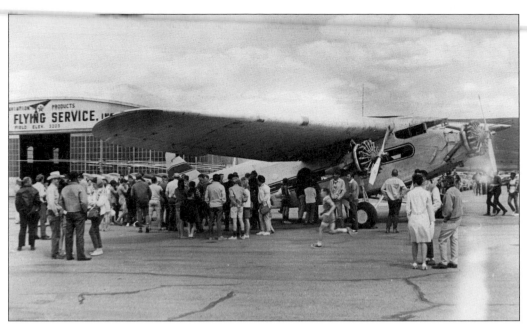

One of the first modern air shows at the Missoula airport occurred in late May 1961. Johnson Flying Service was still a major aviation company at the airport at the time. Above, a crowd views one of Johnson's Ford trimotors, which was its major backcountry aircraft during this period. It served as a smokejumper platform and flew into remote backcountry airstrips in Montana and Idaho. The last one was sold in 1971. After World War II, Johnson Flying Service bought a number of TBM Avenger Torpedo Bombers and converted them to fire bombers and bug sprayers. They were used for years all over North America and were finally disposed of in the early 1970s. In October 2012, the Museum of Mountain Flying in Missoula bought the last Johnson Flying Service bomber and brought it back to the museum as one of its historical plane displays.

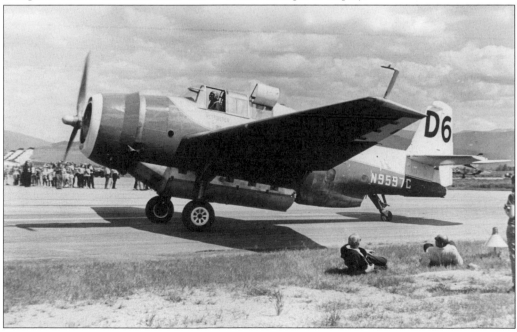

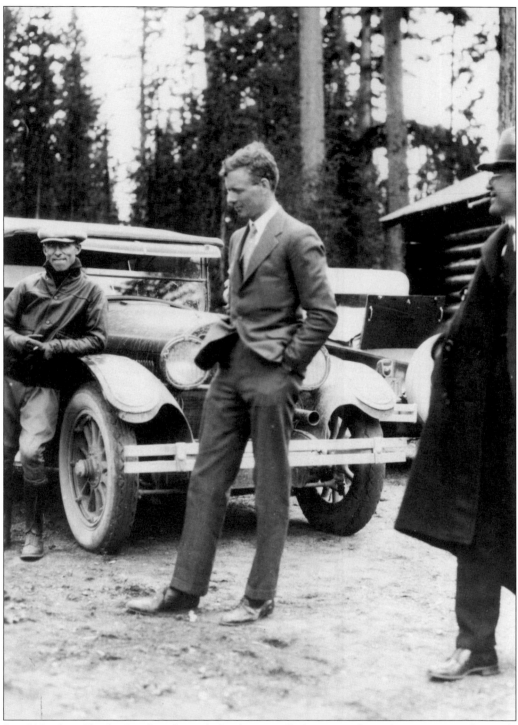

In 1927, after Charles Lindbergh made his historic flight across the Atlantic Ocean, he made an 80-city tour of the United States and Central America. He touched down in every state, and his only recreation stop was in the Seeley Lake-Swan Lake area, where he was taken on hunting trips. Echo Lake was renamed Lindbergh Lake in his honor.

Five

SCHOOLS AND THE UNIVERSITY OF MONTANA

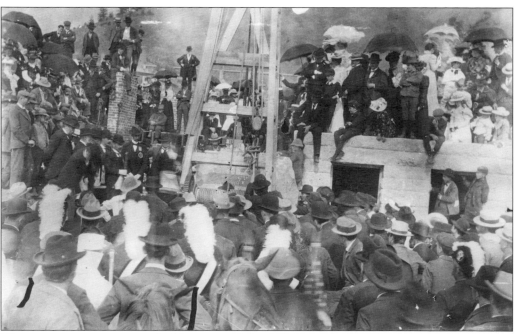

The seven-ton cornerstone for University (Main) Hall was laid on June 8, 1898, symbolizing joy, peace, and plenty. Corn oil and water were poured over the cornerstone. The building was constructed at a cost of $50,000 and now houses the university's administration offices. It was designed by A.J. Gibson, Missoula's most prominent early-1900s architect. He designed several university buildings and other structures in Missoula such as the county courthouse, the Greenough Mansion, Hellgate High School, the Babbs Apartments, and the First Presbyterian Church. (Courtesy of UM: 81-37.)

The University of Montana oval, which was in the original 1895 plan for the new campus, was open to vehicles until the 1950s, when it was changed to a pedestrian walkway. It has been the scene of demonstrations, picnics, and many other events since it was established. The original president's house is to the extreme left. (Courtesy of UM.)

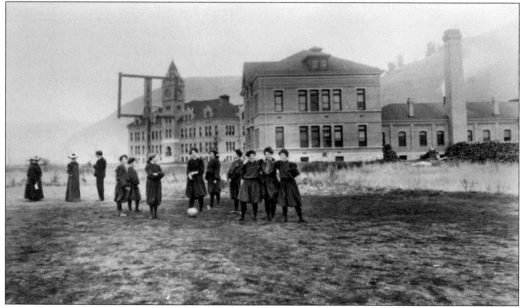

This was the first basketball court on the University of Montana campus, which was outdoors. Main Hall and Science Hall are in the background. Notice the large woodpile behind Science Hall. Indoor games were later played in the old Union Opera House, and in 1903, a wood-shingled gym was completed north of Main Hall. A new gym was opened in 1922, and the present field house opened in 1953.

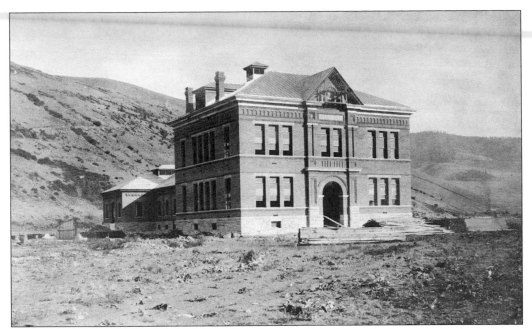

Science Hall is seen here at the end of construction in 1898. It was the first A.J. Gibson building completed on the present campus. It housed all sciences, the engineering school (which later moved to the Bozeman campus), and a museum. It later housed the geology department and was named the Venture Center. It was demolished in 1983; the site is now occupied by the Davidson Honors College Program.

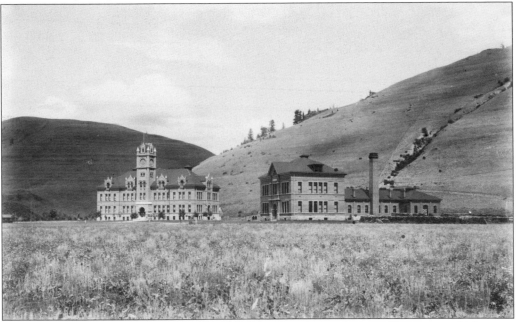

This 1903 view shows the first two buildings constructed on the new University of Montana campus on Missoula's south side. Science Hall is on the right and Main Hall is on the left. Main Hall was opened in 1899. Mount Jumbo is to the left and Mount Sentinel, which is owned by the university, is to the right. (Courtesy of Tim Gordon.)

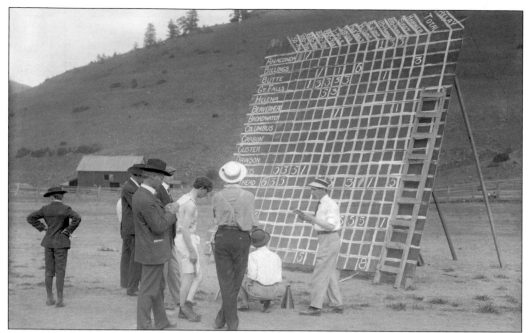

In 1904, the university sponsored an interscholastic meet for high schools in the state. It lasted until 1967. Included were complete track and field events, declamation, and drama. The photograph above shows the track and field scoreboard in the early days of the event. Below is a view of a track meet in 1930 on the university's track. By this time, the grandstand was facing the second Dornblaser Field. The tops of the two buildings just behind the grandstand were built during World War I as barracks for student Army cadets. (Above, courtesy of UM: 014092; below, courtesy of Pictorial Histories Publishing Company.)

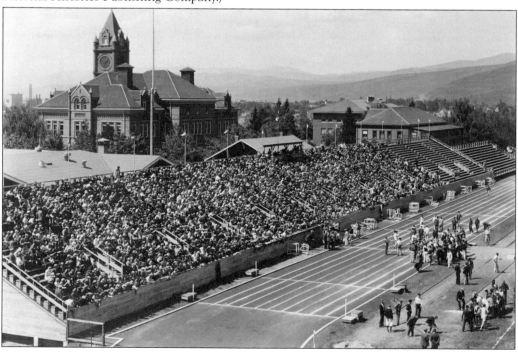

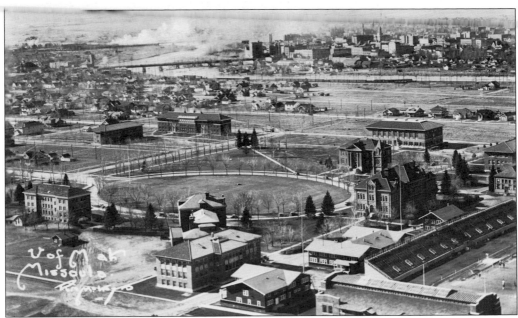

The main part of the campus is seen here in the late 1920s. Dornblaser Field is just behind Main Hall. The men's gym is in the bottom right. The library is just behind the present Rankin Hall on the oval. The Forestry School is just behind the math-physics building on the oval. Several dorms are in the upper left. By this time, the university district is starting to fill in, and the city is in the far background.

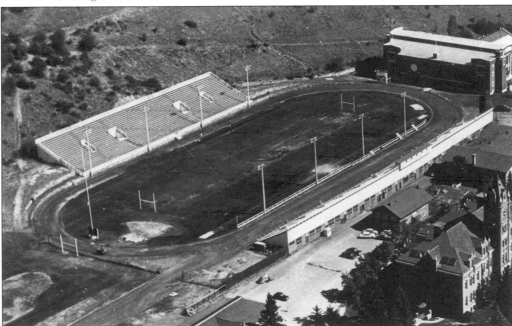

This photograph shows a full view of Dornblaser Field in the 1950s. The stadium was built in 1925 just behind Main Hall as the second Dornblaser Field. The third field was moved to the corner of South and Higgins Avenues in 1968. The present Washington-Grizzly Stadium was built in 1986 and later enlarged to hold approximately 25,000 people.

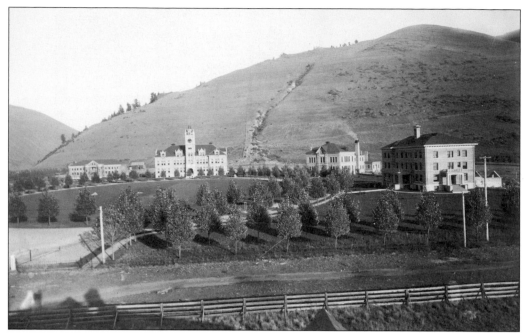

This is a great view of the entire University of Montana campus in about 1905. The first men's gym (1903) is to the left next to Main Hall. The women's hall, at the far right next to Science Hall, was built as a dormitory in 1902 and is now the math building. Trees were planted around the oval in 1896.

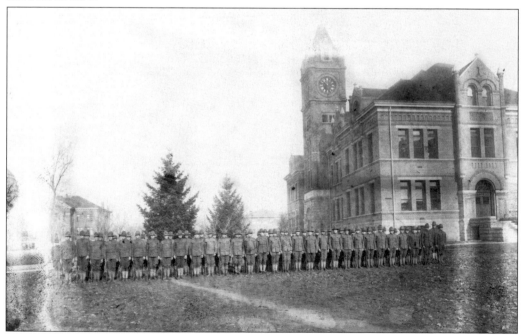

In 1917, a branch of the Student Army Training Corps was established at the University of Montana and at colleges throughout the country. These students were in the regular Army but received an education at many colleges and universities. All the original buildings were designed by well-known Missoula architect A.J. Gibson.

One of the university's most prominent football players was Paul Dornblaser. From 1911 to 1913, he led the teams to 11 wins, 10 losses, and one tie. He was called the best tackle in the west and was captain of the 1912 team. He obtained a law degree and was a deputy county attorney in Missoula County. He was killed at age 30 in France during World War I.

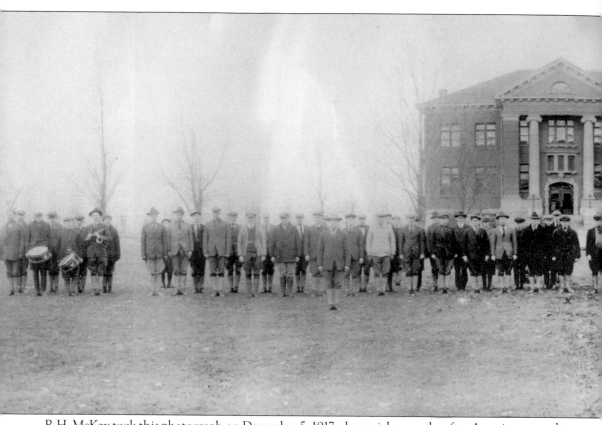

R.H. McKay took this photograph on December 5, 1917, about eight months after America entered World War I. This is the cadet corps from the University of Montana, all of whom have probably just signed up for military service. They are posing in front of the first library, built in 1908, which

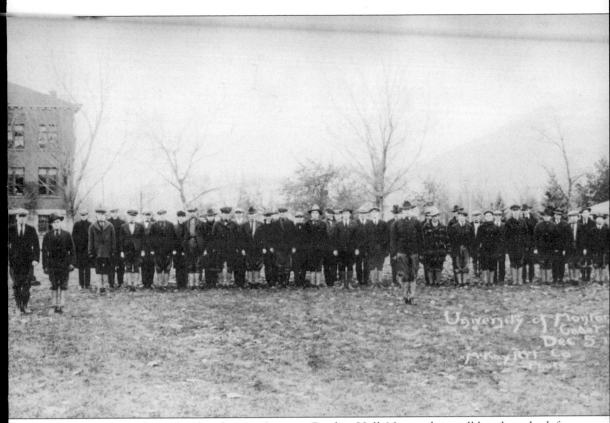

later became the law school and is now Jeanette Rankin Hall. Notice the small band on the left and the different dress of the cadets.

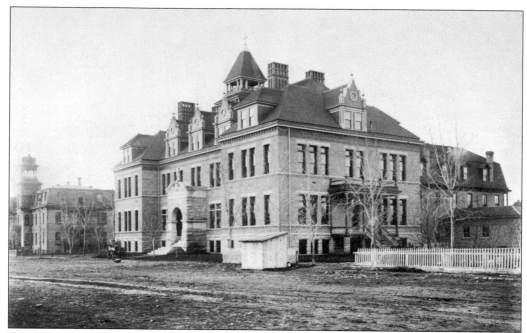

Sacred Heart Academy was designed by A.J. Gibson and dedicated in 1900. It was a Catholic girls' school for many years and became coeducational during the Depression. It closed in the 1970s and was demolished in 1979. This photograph was taken in 1903 after the addition was added to the back. St. Patrick Hospital is to the left. Today, the site is part of Providence St. Patrick Hospital. (Courtesy of Tom Mulvaney.)

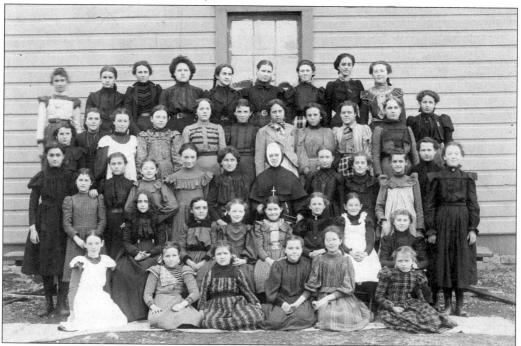

The student body at Sacred Heart Academy poses for a school photograph in the 1890s. Notice the nun in the center.

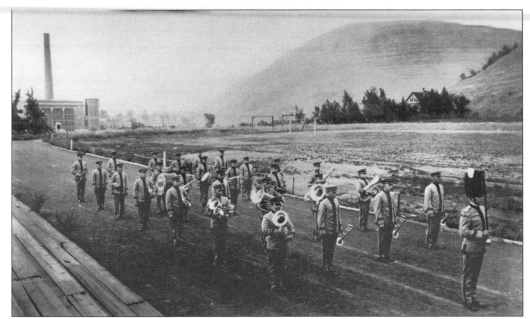

The *Daily Missoulian* newspaper band posed on the original track of the football field in the 1920s. The field was moved to the south in 1925. The present heating plant for the university is to the left. The historic Prescott House, built in 1897, is on the far right. It has been restored and used for various university events. (Courtesy of Claudia Brown.)

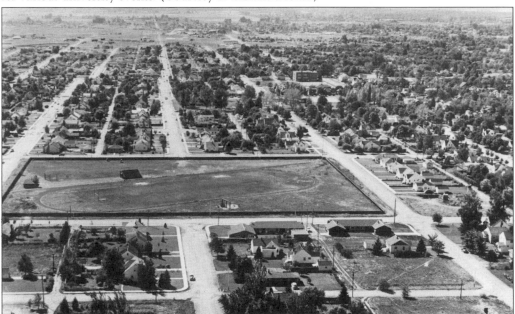

Victory Field, seen here in the 1940s, was the sports field for Missoula County High School. Prior to this field, the football and track teams practiced on several different sites. This field was bounded by Maurice, Arthur, Hastings, and Woodworth Avenues. The school board purchased the property in 1925, and it was first used in 1927. In 1933, public money upgraded the field for track and football. It was named Victory Field in 1934. The field was abandoned and sold after a new field was opened at Sentinel High School in 1957. (Courtesy of UM.)

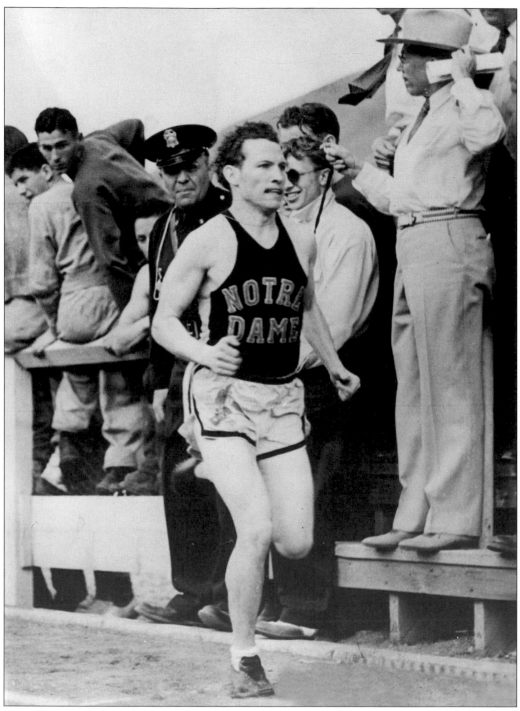

Greg Rice dominated the long-distance running scene in Montana in national high school races and in college in the 1930s. He graduated from Missoula County High School in 1935 and attended the University of Notre Dame, winning many collegiate races. He was given the Sullivan Award, as the nation's top amateur athlete. He served in World War II and became an attorney. Rice died in 1991 at age 75.

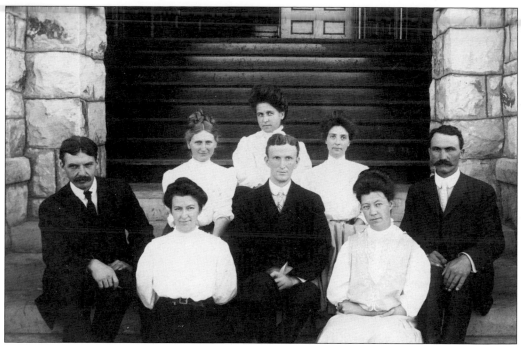

Teachers at Missoula County High School pose at the old high school building on South Sixth Street in 1907. They are, from left to right, (first row) Professor Steger, civics; Miss Jamson, botany; Prof. J. Franklin Thomas, mathematics; Caroline Wakeman, history; (second row) Margaret James, Latin; Miss Chrisholm, German and English; Miss Spencer, English; and Professor Greens, mathematics. (Courtesy of UM.)

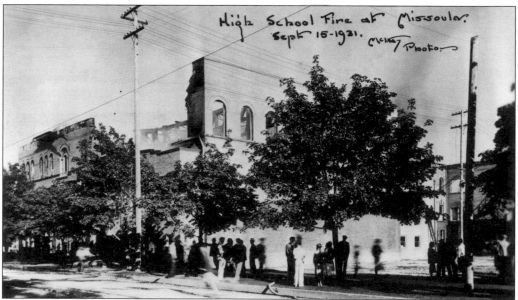

On September 15, 1931, Missoula County High School was partially destroyed by fire. This view shows the southwest corner of the new south wing, which was built the same year. Part of the brick wall that collapsed was used in the rebuilding, replacing the vaulted roof with the present flat roof. (Courtesy of UM.)

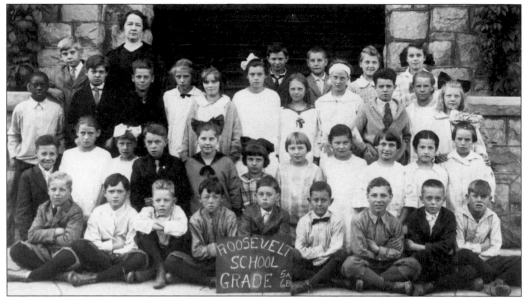

The students of grades 5A and 6B gather on the steps at Roosevelt School on South Sixth Street in the early 1930s. The school was opened in September 1904 as a four-year high school. The building became a grade school in 1908 when a new high school building was opened. It was named for Pres. Theodore Roosevelt until the new Roosevelt School on Edith Street opened in 1954. Since then, it has served as offices for the Missoula County Public Schools.

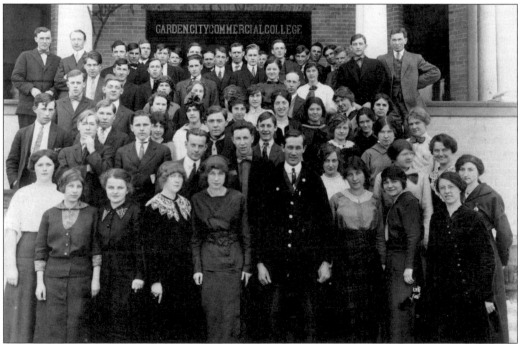

Students and faculty of the Garden City Commercial College on South Fourth Street pose in 1912. The building was designed by well-known Missoula architect A.J. Gibson and opened in 1905. The building was an example of Queen Anne–style commercial design. Later, it was converted to apartments, The Babs, and it has been recently restored. (Courtesy of UM.)

The original Central School was built in 1887 at the corner of East Broadway and Adams Street. It was torn down in 1935 and the present building was erected through the Works Progress Administration. An annex was added later. Until 1904, the building was used as a grade school and high school. The school closed in 1981 and was used until 1990 for extension classes and by the Head Start Program. After several different financial transactions, the Missoula Children's Theater took over the building and opened in October 1993. After extensive remodeling, the building later reopened again as the MCT Center for the Performing Arts. (Courtesy of Steve Bixby.)

The present Lincoln School was originally a wooden building on part of the county poor farm in the upper Rattlesnake area. The present school site was bought in 1910, and the frame school building was moved to the site in 1911. The present school was built in 1914 for $10,852. After many years of use, the remaining students moved to the present Rattlesnake School in 1961. For the next three years, it was occupied by the state forester's office. From 1964 to 1982, the building was reopened for various school classes. A church was the last tenant before the building was sold to a private developer. (Courtesy of UM: 013802.)

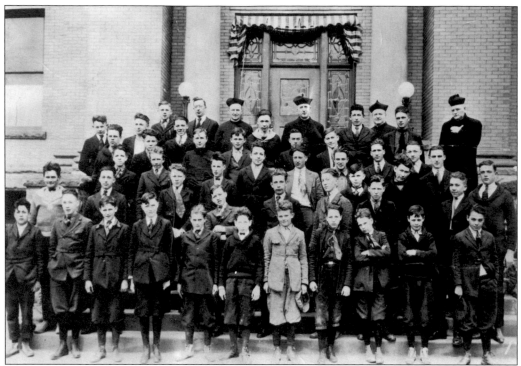

Loyola High School students pose in front of their school building in the Catholic Block on Pine Street. The high school was founded in 1909 by the Society of Jesus and Father Albert Trivelli, S.J., as a boys' high school. Notice the dress code in the early years—coats and ties. In 1974, the school was closed and it merged with Sacred Heart Academy, the girls' school, to form the Loyola-Sacred Heart Foundation. The new school moved to the former St. Anthony's grade school on Edith Street. The Loyola High School football team is seen below in 1923. (Both courtesy of Donna Hart.)

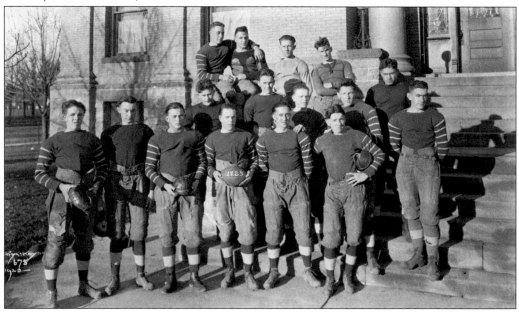

Six

US FOREST SERVICE

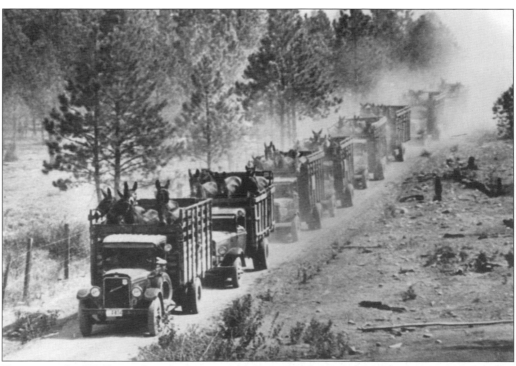

Ever since the US Forest Service began, pack animals—horses and mules—have been used to carry supplies to lookouts for building purposes and for firefighting. They were housed at the Ninemile Remount depot and loaded on these 1930s trucks to be taken to a trailhead.

Trucks from the Civilian Conservation Corps (CCC) are unloaded in Missoula from a Milwaukee Railroad train in August 1933. They would be dispersed to CCC camps throughout the western Montana area. Fort Missoula would become the regional administrative headquarters for the organization. The CCC program started in 1933 and ended in July 1942.

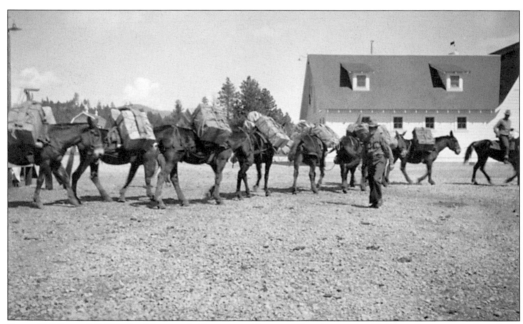

From 1930 until 1953, the Ninemile Remount Depot, 25 miles west of Missoula, provided packers and pack strings from its base, which was constructed by Civilian Conservation Corps members in the early 1930s. By 1953, smokejumpers and airplanes had taken over the firefighting duties, and the depot was phased out. Today, the depot is on the Ninemile Ranger District, and the mules are still used for work and as a historical attraction. (Courtesy of Steve Bixby.)

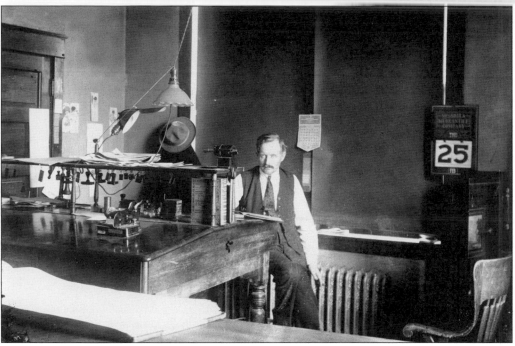

The first Lolo National Forest supervisors' office of Region One of the US Forest Service was in the Hammond Building. The region was the first regional office established in 1908, three years after the start of the organization. In the above photograph, note the long desk and the row of hanging rubber stamps used for making entries in the ledgers, as well as the Smokey Bear hat hanging on the wall. The photograph below shows a typical meeting with an old-style telephone and maps and documents scattered on the table. From this office, orders were sent to the various supervisors' offices and ranger districts in the region, from northern Idaho to eastern Montana. (Both courtesy of the US Forest Service.)

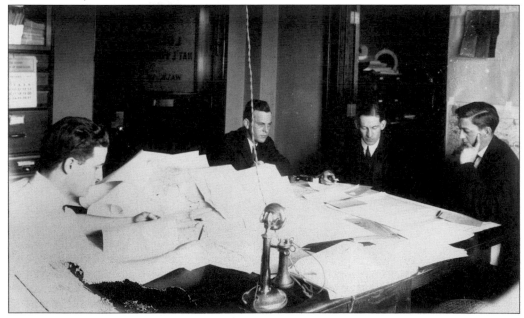

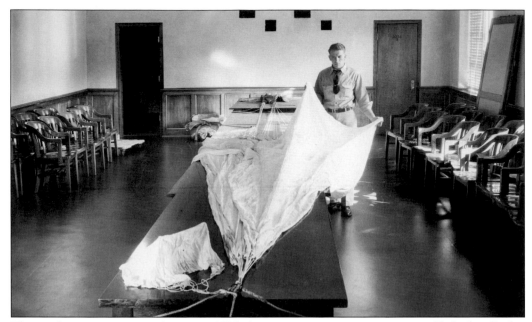

The smokejumper program began in 1939. A temporary jump center was established at Seeley Lake, 50 miles from Missoula, in 1940, and in 1941, the base was moved to the former Stoney Creek Civilian Conservation Center near the Ninemile Remount depot. Above, Chet Derry, one of the pioneers of the program, packs an Eagle parachute in the conference room of the federal building in Missoula in 1940. Below, smokejumpers mend chutes in the Park Hotel on Higgins Avenue in 1943. (Both courtesy of the US Forest Service.)

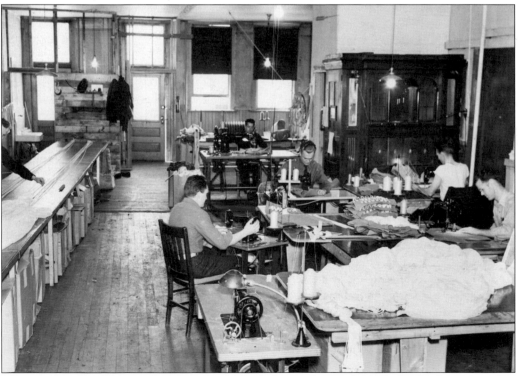

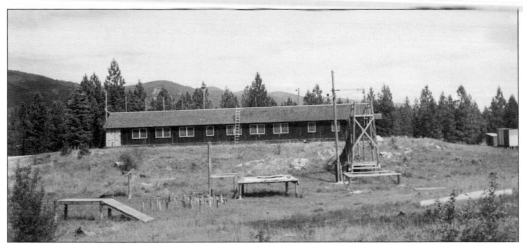

In 1943, the smokejumper center moved down the road from the CCC camp to Camp Menard for training purposes. Small planes took off for fires from the small landing strip just west of the Remount depot. The DC-3 was boarded at Hale Field if a large contingent of jumpers was needed on a fire. The mules were used to haul out the equipment after the fire. (Courtesy of the US Forest Service.)

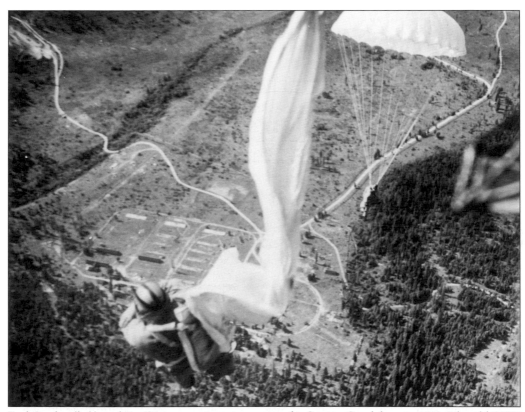

Earl Cooley (left) and Jim Waite practice a jump over the Stoney Creek base in 1941. The old CCC camp is below them. Cooley was on the first actual fire jump with Rufus Robinson on a fire in the Nez Perce National Forest in Idaho on July 12, 1940. (Courtesy of the US Forest Service.)

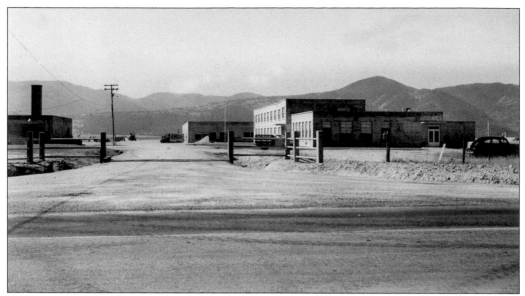

The Aerial Fire Depot, just west of the Missoula Airport, was dedicated in 1954, when all firefighting facilities from the Ninemile camp and Hale Field were moved to the present airport. It is the largest base of its kind in the country. This photograph shows the entrance soon after its opening, with the dorm/training center on the right, the warehouse in the back, and the west part of the loft building. (Courtesy of the US Forest Service.)

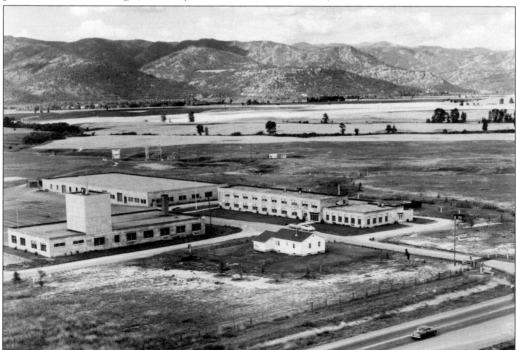

This aerial view was taken about the same time with a full view of the parachute loft (left) and the dorm/training building and the warehouse. Through the years, there has been much expansion of the facility, including a hangar for US Forest Service aircraft. The training area is in the background. (Courtesy of the US Forest Service.)

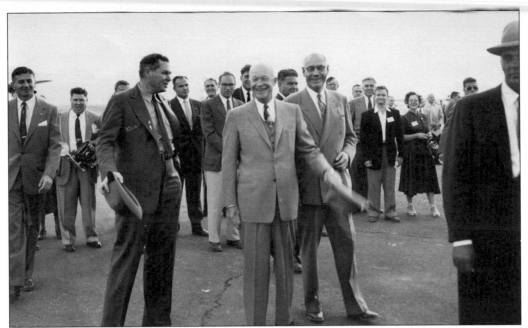

The dedication of the Aerial Fire Depot took place on September 22, 1954, with a crowd estimated at 30,000—the largest in the state's history up to that time. Seen here are, from left to right, Richard McArdle, the chief forester of the US Forest Service; Pres. Dwight D. Eisenhower; and Gov. Hugo Aronson. The president put on a smokejumper helmet and was made an honorary member of the smokejumpers. (Courtesy of the US Forest Service.)

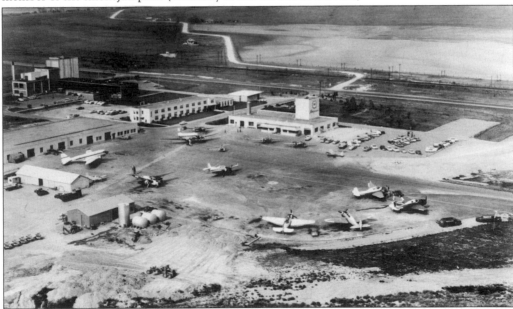

The Aerial Fire Depot was the headquarters for all aircraft activity since it began in 1954. This 1960 photograph shows many types of aircraft for smokejumpers and dropping fire retardant. Today, of this group, only a modified DC-3 is still in use. The building and the tanks in the lower left are the mixing area for the fire retardant dropped by some of these planes. The building at the top left is a fire research lab. (Courtesy of the US Forest Service.)

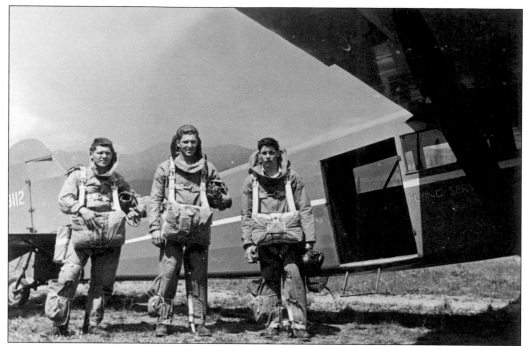

Three jumpers, two of them from the Civilian Public Service (CPS), are shown ready to board a Travelair 6000 in 1943 for a practice jump. The CPS were conscientious objectors who performed public service during World War II. With most smokejumpers in the military, the CPS program provided most of the smokejumpers to fight fires in the west. From left to right are Al Cramer, who was not a CPS; Phil Stanley, the official photographer; and Dave Ratigan. (Courtesy of the US Forest Service.)

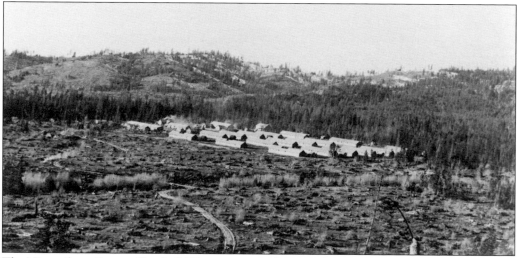

The Ninemile or Stoney Creek CCC camp is seen here in the 1930s. The corps was established nationally in the New Deal era in 1933 and ended in 1942. More than three million "boys" enrolled during that nine-year period, with many camps in Montana doing conservation work. This camp was the largest in the country and was controlled from the Fort Missoula regional headquarters. Some of the buildings from the camp are still scattered around Missoula. (Courtesy of the US Forest Service.)

Seven

STREET SCENES

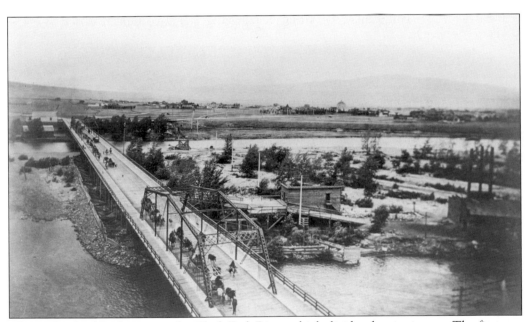

This is the third bridge across the Clark Fork River, which divides the city in two. The first was built in 1869, and the second, the Rankin Bridge, was built in 1873 as an extension of Higgins Avenue. This bridge washed away in the flood of 1908. The island at one time had an ice-skating rink on it, as well as a carpenter shop and a steam plant that provided heat to buildings in downtown Missoula.

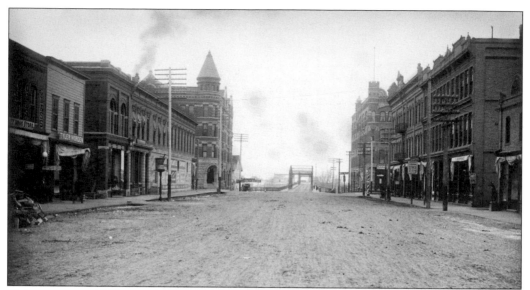

This expansive 1898 view looks south on Higgins Avenue toward the Clark Fork River. The sidewalks were wooden and all the streets were dirt. The Missoula Mercantile is just past the sidewalk drugstore sign on the left, the First National Bank is next, and the original mill is on the left at the bridge. On the right are the Florence Hotel and the Hammond Building at the far end of the street.

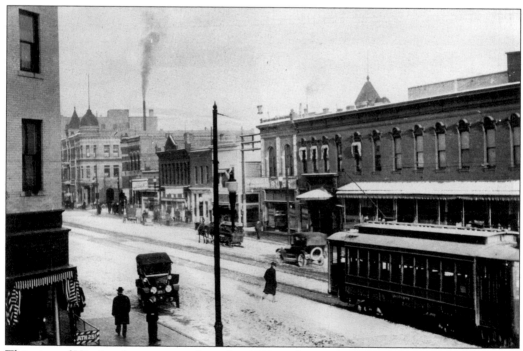

This view of Higgins Avenue was taken after 1910, as the new streetcar company is in operation. The corner of the Florence Hotel is on the left, the Higgins Block is in the background, and part of the Missoula Mercantile is on the right showing the canopy on the north end of the building. The next building was eventually incorporated into the mercantile store. (Courtesy of Bob VanGieson.)

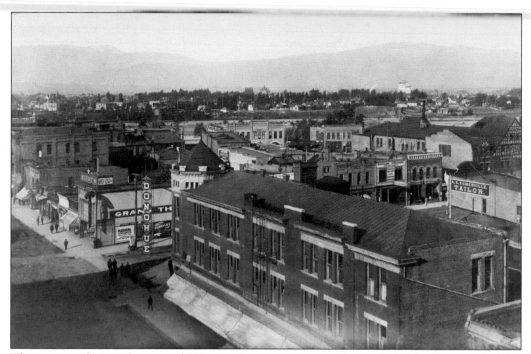

The corner of Main Street and Higgins Avenue is seen in this early-1900s photograph. The Donohue Building was built in the 1880s and was first known as the Daly Block. It was later occupied by the D.J. Hennessy store and then the Donohue Store. The Grand Theater is across the street and the Missoula Hotel, which still stands, is on the far right. In the background across the river is the old Willard School and the Ravalli Mill.

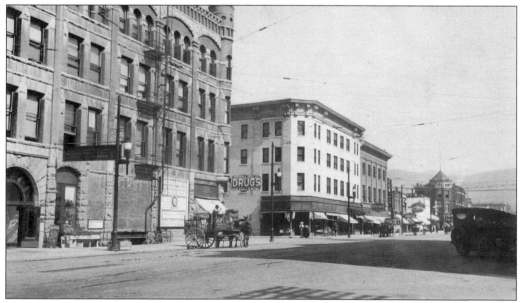

The west side of Higgins Avenue is seen here with the second Florence Hotel, built in 1913. The Hammond Building is on the far left side, with Front Street between the two buildings. Missoula Drug Co. was one of the oldest drugstores in town. The Donohue Building is the building down from the hotel at the Main Street intersection. Notice the two horse-drawn hacks on the street.

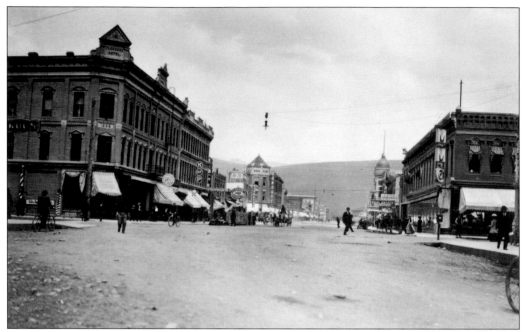

This 1909 view looks south on Higgins Avenue. The first Florence Hotel, built in 1888, is at the corner on Main Street. The Donohue Building is down the street on the left. The Missoula Mercantile, with its massive MMC sign, is on the right, with the Higgins Block down the street. By this time, the downtown area was the business center of western Montana. (Courtesy of MHS: 949-488; photograph by John Maloney.)

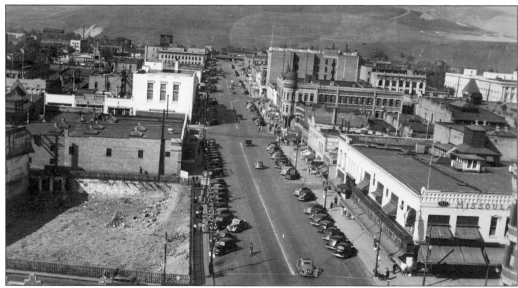

The Florence Hotel burned down on September 24, 1936, so this postcard view was probably taken later in the year, as all the debris has been removed from the lower left area. The Missoula Mercantile across the street was painted white at this time. The white building on the left is the new Montgomery Ward store, completed in 1935. The federal building is the large gray building on the far right.

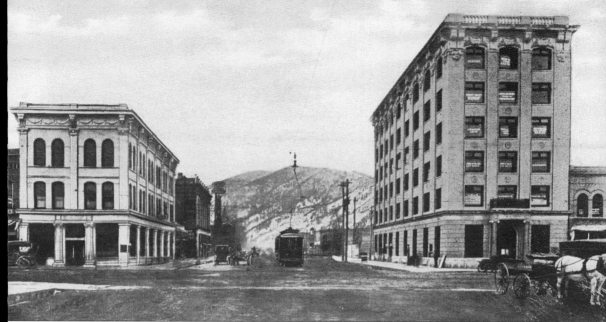

This postcard is dated 1919. On the left is the Scandinavian-American Bank, designed by A.J. Gibson, the well-known local architect whose office was in the building. It was constructed in 1890 and was used as a bank until 1931, when the Western Montana Savings and Loan Association moved in. It was torn down in 1955 for the present building, which is now part of the First Security Bank system. The building on the right is the Montana Building, which was built in 1910 for the Western Montana National Bank, the second bank chartered in Missoula, in 1889. Today, the facade has been modernized and is used for retail and office space. Broadway, formerly Cedar Street, is the main east-west street downtown, intersecting Higgins Avenue.

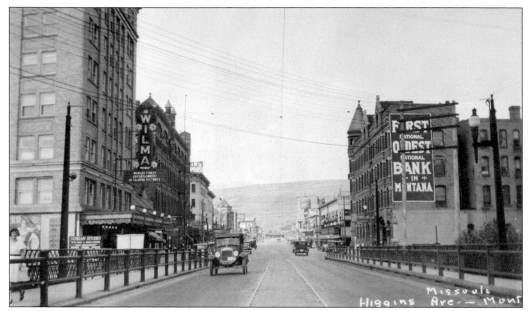

The Wilma Theater is partially seen on the left with its large sign. This photograph was taken before 1932, as the Hammond Building is still standing, as well as the second Florence Hotel. On the other side of Higgins Avenue is the First National Bank, with its large sign. The Wilma sign was taken down many years ago, but it has since been reproduced and put back on the building.

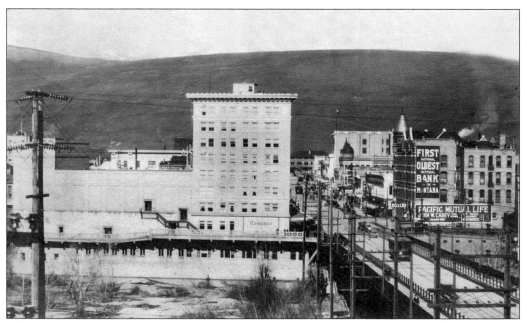

This 1920s view of the Wilma Theater shows the Clark Fork River flowing right beside it. The Wilma opened in 1921 and has been the showplace of Missoula since, with movies, stage shows, apartments, restaurants, and even a swimming pool in the basement at one time. The 1909 Higgins Bridge is seen here along with the major buildings in the downtown area.

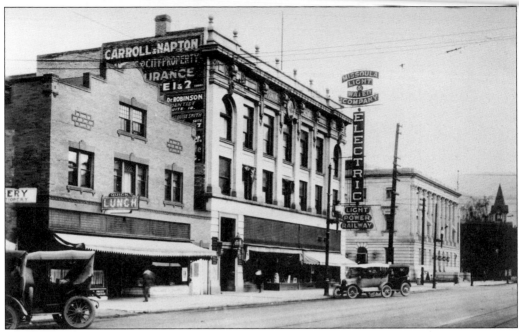

These two views show Broadway, the main east-west route through Missoula. It was originally called Cedar Street and is the old Highway 10, which has been largely replaced by Interstate 90. The photograph above was taken between 1910 and 1912, as the first part of the federal building on the far right was completed in 1913. The Masonic Temple was built in 1909 and is the only Beaux Arts building in the central business district. It housed William A. Clark's electric, light, and power company for years. It houses several Masonic orders and retail stores on the street level. The photograph below shows the same scene in 1948, with Montana Power as the successor to Clark's business. The large building to the left was the Scandinavian-American Bank, which was torn down in 1955.

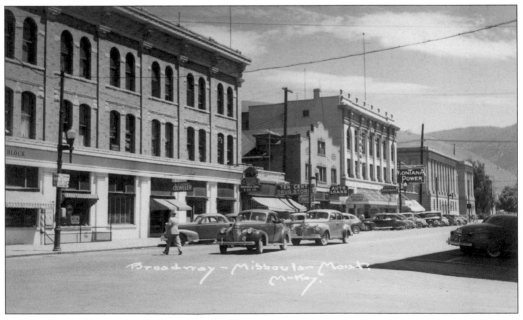

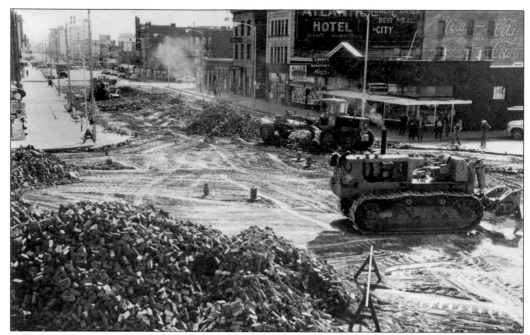

Higgins Avenue and the major side streets in downtown Missoula were bricked in 1912. This view is from 1962, when the brick was removed and the streets were paved. This is the corner of Higgins Avenue and Alder Street, in front of the railroad depot. A new bridge at the end of Higgins was built, and Caras Park was created with a change in the river's channel.

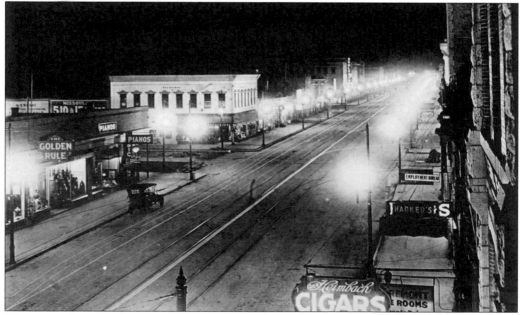

This unusual view is from around 1915. The caption on the photograph, "the best lighted street in America," may have been a promotional statement. The Golden Rule Store was owned by the J.C. Penney Company. Hogt-Dickinson was the piano company on the corner of Broadway and Higgins Avenue. D.C. Smith is the white two-story building across from the piano store, which was built in 1890. The First National Bank is on the right.

Eight

GOVERNMENT, CHURCHES, AND HOSPITALS

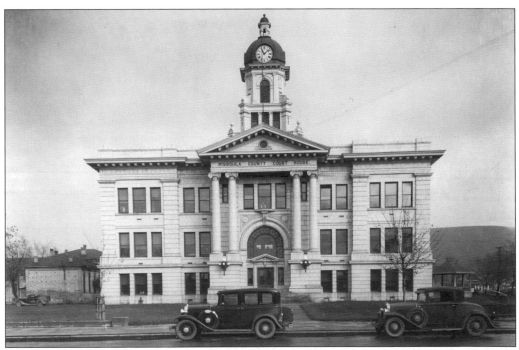

The Missoula County Courthouse was designed by A.J. Gibson and opened in 1910. The old jail is the building on the left. Two 1931 Chevrolet automobiles are in front of the building. The bandstand on the right was uncovered for its first few years. Later, a cover was put on it. Native sandstone and terra cotta, rather than granite, was used in the courthouse construction. The columns are Doric-style on the basement level, Ionic on the main floor, and Corinthian on the second level. The dome has clocks on the four sides of the tower and is covered by galvanized iron panels. An annex to the north side was added in 1967, but takes away some of the historic character. Artist Edgar S. Paxson painted a series of historic scenes that are mounted on the walls of the foyer.

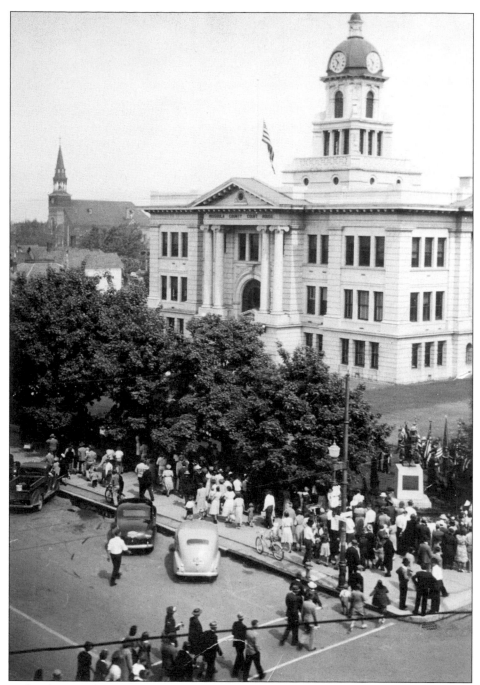

A crowd gathers at the courthouse in 1941, possibly for Memorial Day. St. Francis Church is in the left background. The "Spirit of Doughboy" statue in the lower right was a type that was set at locations throughout the country. It was designed in 1920 and was made of more than 70 pieces of individually struck sheet copper (later zinc) and welded together over a steel under-frame, then bronzed. The price was about $1,500. Plaques are placed on two sides listing World War I and II dead from the greater Missoula area. The statues were sponsored by the American Legion. Notice the flag is at half-staff.

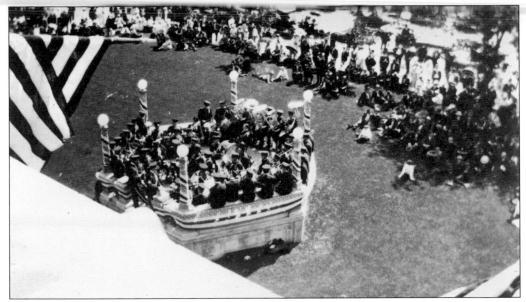

The bandstand on the Missoula County Courthouse lawn was the scene of a band concert from the University of Wisconsin band, which was in town for the 1915 Missoula Stampede. This was before a roof was put on the bandstand. The concrete bandstand was later removed when the annex was built. A reproduction of the bandstand was built on the front lawn of the courthouse recently and is used for public events. (Courtesy of Barbara Finn.)

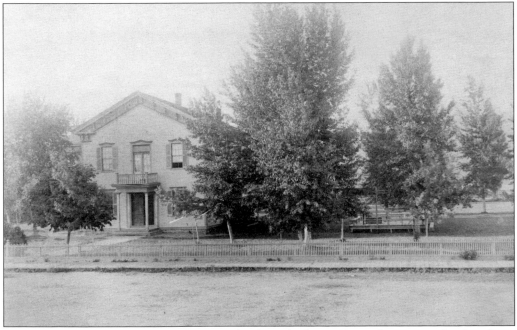

The first Missoula County Courthouse and jail was built in 1871, and a separate brick jail was added in 1889 on the west side of the courthouse. Most of western Montana was part of Missoula County at the time. When the new Missoula County Courthouse was opened in 1910, the original building had already been moved to its present location on the north side of Missoula. It was reconfigured and split into apartments.

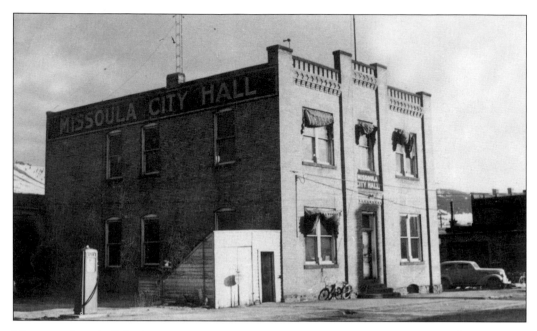

The second city hall, built in 1910 on Ryman Street, is seen above. All the main city offices except the fire department and the police department were in this building. The first city hall (page 23) remained the fire department for years. The same building is seen below in 1953. This building was demolished in 1970 and a new modern city hall was built on Spruce Street. The top of the Missoula County Courthouse is on the left.

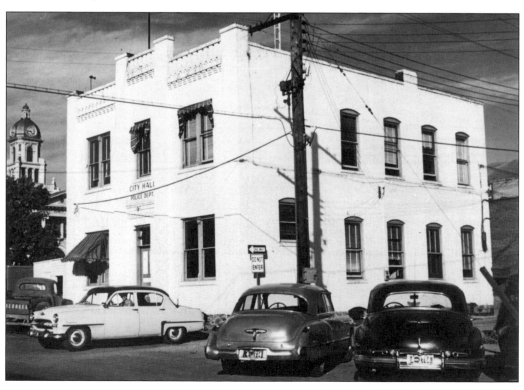

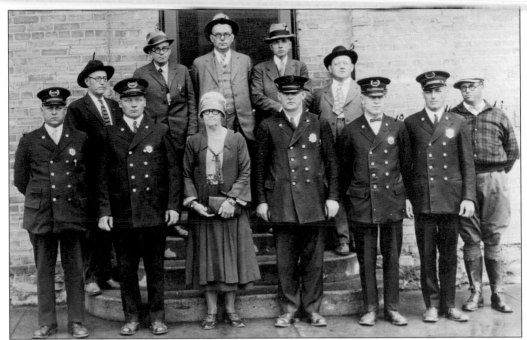

The Missoula Police Department is seen here in 1926. The officers were paid $135 per month. They are, from left to right, (first row) patrolman Oscar Morin; unidentified; matron Mrs. Wilburn, ; Gus Peterson; unidentified; Bill Winters; and motorcycle patrolman Orville Woodgerd; (second row) unidentified; Dan Pease; Chief Ira Johnston; Mayor R.W. Kemp; and desk officer Harry Kath. (Courtesy of Lou Henes.)

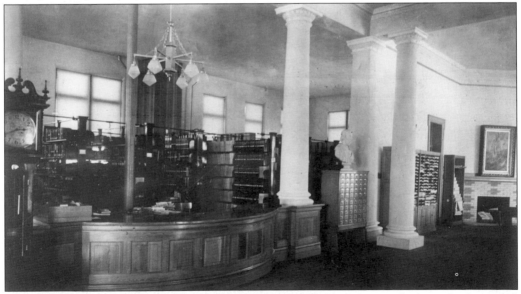

This photograph shows the interior view of the Carnegie Public Library, which was built in 1902 on Pattee Street. The city purchased the lot and built the one-story library with $12,500 provided by the Carnegie Foundation. A.J. Gibson designed the building. In 1913, a second story was added, designed by Gibson's assistant, Ole Bakke. In 1974, a new library was built and the old building became the Missoula Art Museum. (Courtesy of UM: 81-378.)

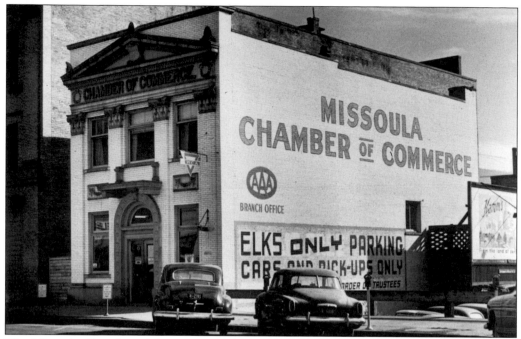

The Missoula Chamber of Commerce building is seen here in 1953. It was built on East Main Street in 1905 as the Independent Telephone building. It has housed the telephone company, the chamber of commerce, union offices, law offices, and retail stores. The chamber moved into this building in 1916, and a new chamber building opened in 1976. (Courtesy of MHS: 949-356.)

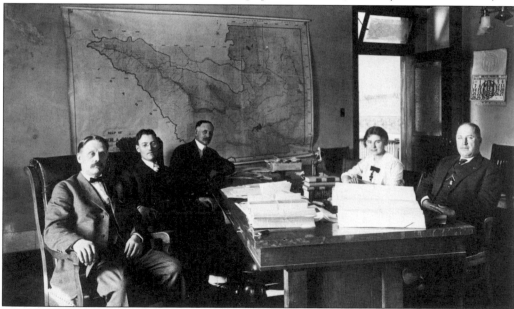

Missoula county commissioners posed for this photograph in 1913. Missoula County was established in the Washington Territory in 1860 and then came to include most of western Montana in the Montana Territory and the state from 1864 to 1893. In 1893, Ravalli and Flathead Counties were split off, followed by Sanders County in 1905, Mineral County in 1914, a Powell County boundary change in 1915, and Lake County in 1923. (Courtesy of UM: 82-210.)

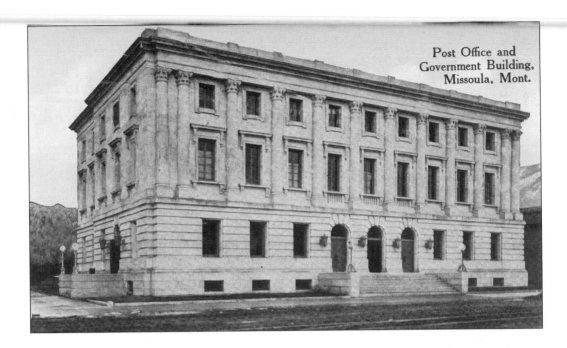

The post office and government building on East Broadway was started in 1911 and completed in 1913. It was an impressive building for Missoula at the time. It is a three-story masonry construction building with a granite foundation. It was built in a Renaissance Revival motif. A western addition was completed in 1928 and became the headquarters for Region One of the US Forest Service. The photograph above shows only the original structure. The photograph below shows the two parts of the building in 1931 facing Broadway, and the Forest Service wing, which opened in 1936, on the left. Two additional post offices have been built since in the city.

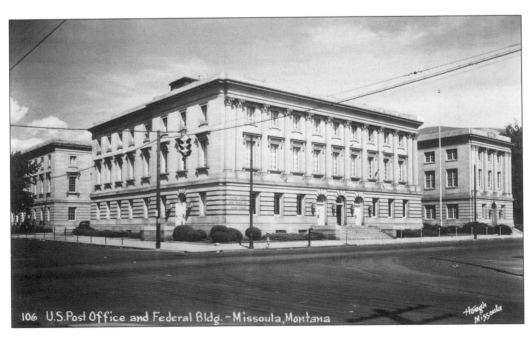

106 U.S. Post Office and Federal Bldg. – Missoula, Montana

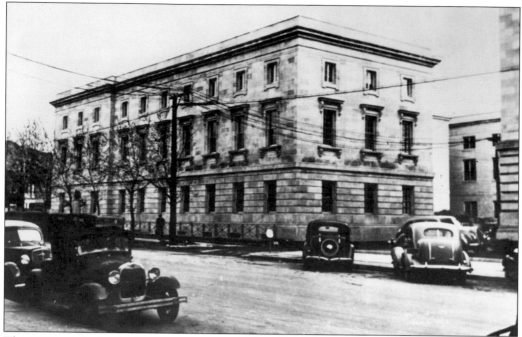

This 1940s view shows the Forest Service addition, which was completed in 1936, facing Pattee Street. For years, all Forest Service offices for the region were concentrated in the federal building downtown. But as the agency got bigger, the Lolo Forest supervisors' office and the Missoula Ranger District moved to Fort Missoula, along with other departments. Some of the departments were also moved to other cities outside of Montana.

The Church of the Holy Spirit (Episcopal), at 130 South Sixth Street, was founded by Rev. George Stewart in 1870. A brick church was built at Adams Street and Broadway, later the site of Central School, in 1884. The present site was purchased in 1914, and a new brick church was completed in 1918. The rectory was completed in 1933 and an addition, the parish hall, was built in 1954.

St. Francis Xavier Catholic Church opened in 1892 on West Pine Street and is one of the most prominent buildings in the downtown area. The oldest Catholic presence in the Missoula Valley was St. Michael's Chapel, built by the Jesuits in 1863 near the old Hellgate village site. It was moved to the Historical Museum at Fort Missoula in 1981, where it is used to interpret the history of the missionary movement in the area. (Courtesy of UM: 98-7.)

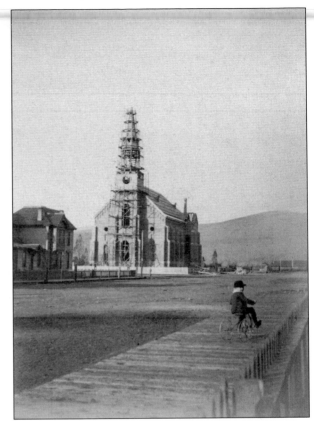

The finished church is seen below in 1903 from Orange Street. The church to the left was built in 1881 and served the Catholic community until St. Francis Xavier opened in 1892. The entire block to the west now includes the rectory, the former Loyola High School, and the large St. Patrick Hospital complex. The St. Francis grade school was torn down recently and is now a parking lot. (Courtesy of Tom Mulvaney.)

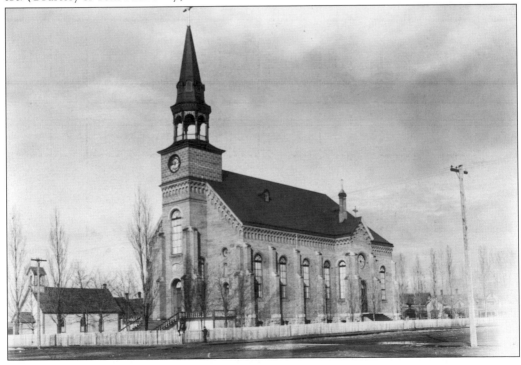

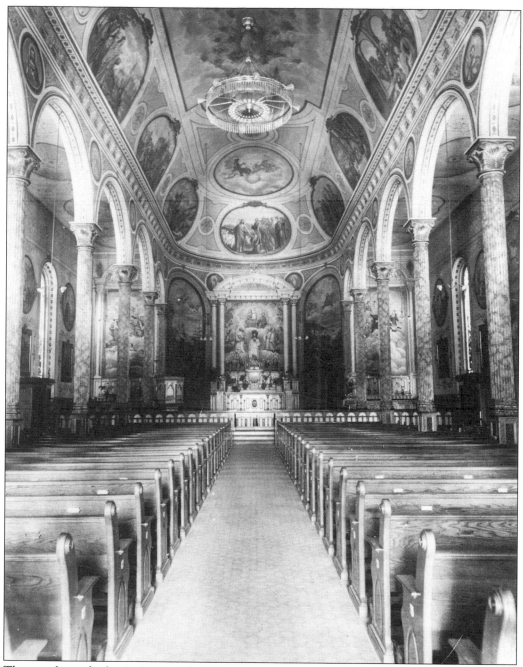

The murals inside the St. Francis Xavier Church were painted by Brother J. Carignano, who also painted the murals at the St. Ignatius Mission, 50 miles north. This photograph is from 1913. Fr. L.B. Palladino, a noted author on Indian-white relations in Montana and a participant in the Roman Catholic Christianizing efforts among the Native Americans, served as pastor for many years. The bell in the steeple is dedicated to Father Palladino. The church and the murals have been placed in the National Register of Historic Places. (Courtesy of UM: 77-236.)

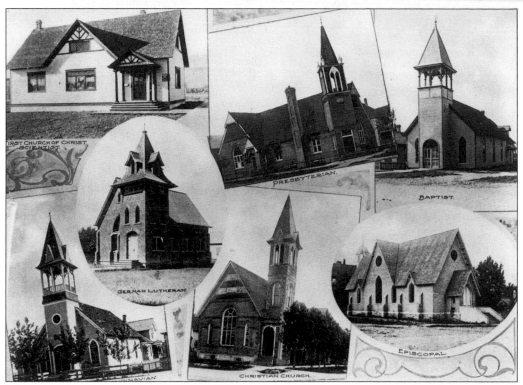

This early-1900s postcard shows most of the churches in Missoula. None of these buildings have survived, with many denominations building new churches and some disappearing from the area. Many new religions have been established in the area, including Seventh-day Adventist, Jewish, Mormon, Methodist, Jehovah's Witness, Greek Orthodox, Community Church, and many others. (Courtesy of UM: 76-168.)

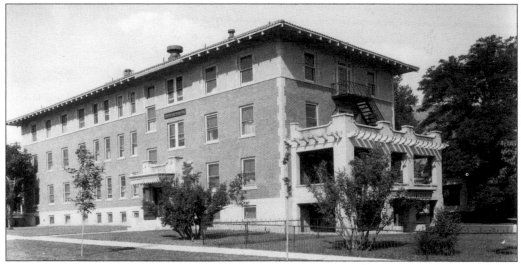

Community Hospital had its roots in the Thornton Hospital, which was started by two brothers. The first hospital was built at the corner of Third and Orange Streets. In 1922, they built this hospital in the 300 block between East Front and Main Streets, now the site of the Missoula City-County Library. It had 42 beds. Today, the Community Hospital complex is located at Fort Missoula.

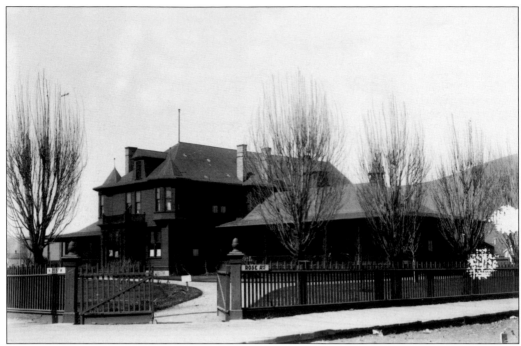

The first Northern Pacific Railroad hospital was constructed at 300 North Second Street in 1888. It was owned by the Northern Pacific Beneficial Association. It burned down in 1892 and this building replaced it a year later. An addition was added in 1901. In 1916, the hospital partially burned and a new building was constructed. (Courtesy of Steve Bixby.)

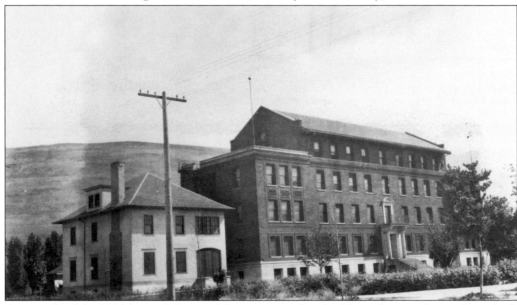

As a result of the 1916 fire and the need for a more modern building, this new hospital was built in 1917 with 116 rooms. In 1967, the name was changed to the Missoula General Hospital, and it operated until 1984. These buildings were torn down in the 1980s, and a new building was constructed and is now operated by St. Patrick Hospital as the Providence Center. (Courtesy of UM: 90-74.)

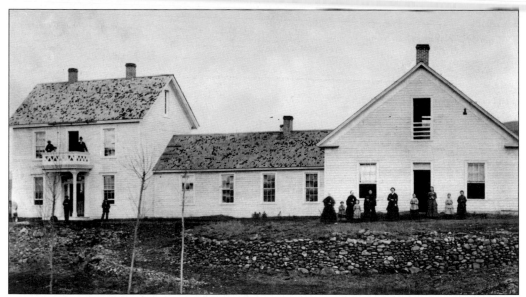

The first hospital and school building (right) opened in 1873 in a former residence. It was later purchased by Fr. L.B. Palladino from Washington J. McCormick for about $1,500. The building on the left was erected as a hospital in 1882. The connecting building was the Sisters of Providence Convent. In 1889, A.J. Gibson designed the new building at this site, which was demolished in 1965.

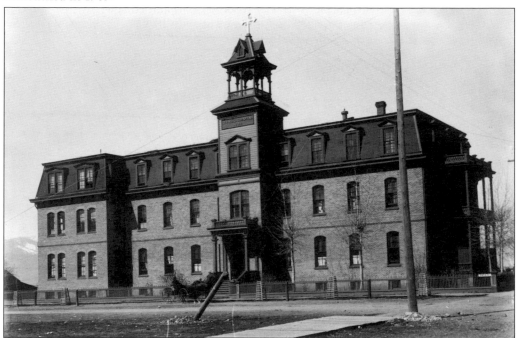

In 1889, the new hospital building was built for $23,750 and faced Owen Street. It was a three-story brick building with a basement. There were 24 private rooms and four wards, which could accommodate 80 to 90 patients. It also had a chapel, an apothecary's room, a surgeon's room, waiting rooms, and a bathroom. The Sisters moved the patients into the new building on January 9, 1890. (Courtesy of Steve Bixby.)

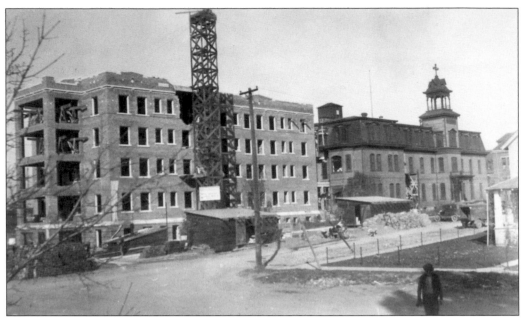

Several additions were made to the 1889 building between 1917 and 1919 in order to make room for an X-ray machine and a laboratory. This previously unpublished photograph was taken in 1923, when a major addition was built. There are no windows installed yet and the hole at the top is a mystery. (Courtesy of Steve Bixby.)

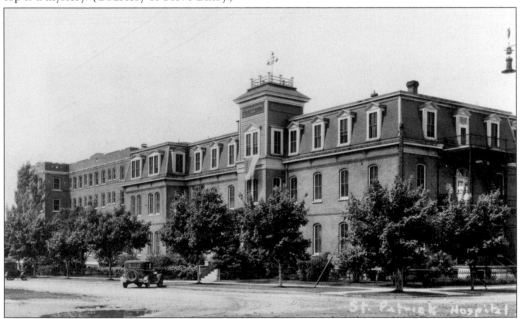

The hospital is seen here in the early 1930s. The cupola was probably taken down in the early 1930s. The original St. Patrick hospital 1889 sign can be seen right below where the cupola was. In 1952, the Broadway Annex was built and the original 1889 building was turned into a house for the Sisters on the hospital staff. The original building was torn down in 1965, and other buildings were torn down for the Providence St. Patrick Hospital in 1984. The Broadway Building, which houses the Western Montana Clinic, the hospital, and doctors' offices, was built in 2002.

Nine

BUSINESS AND INDUSTRY

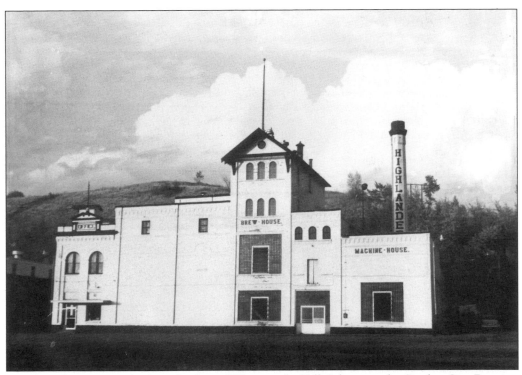

In 1894, a brewery was built at the foot of Waterworks Hill. It became the Garden City Brewing Company. The building is seen here in the late 1930s after it was remodeled and Prohibition had ended. It had reopened as Sick's Brewing Company, with "Highlander" as its brand name. The company closed in 1964 and the building was demolished to make way for the new Interstate 90 right-of-way. The first brewery in Missoula opened in 1870 by the river and Higgins Avenue, and today, several microbreweries have started up in town.

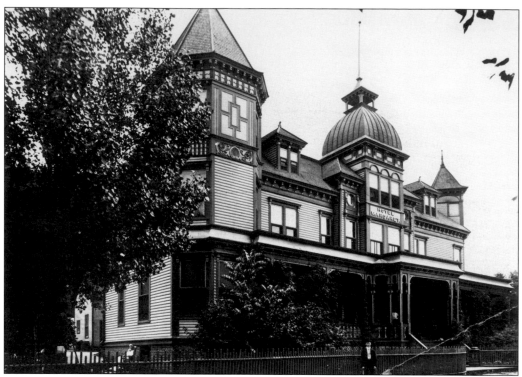

These two views show one of Bonner's most prominent structures, the Hotel Margaret, near the Anaconda Copper Mining Company's lumber mill. It was torn down in 1957 after 65 years of use as a hotel and social center for the Bonner community. The hotel was named for Margaret Hammond, the daughter of A.B. Hammond, one of the early lumbermen of Bonner and a leading Missoula businessman. The three-story hotel opened in August 1892 with an ornate Victorian-style building. People would drive or take the streetcar out to Bonner on Sundays for dinner.

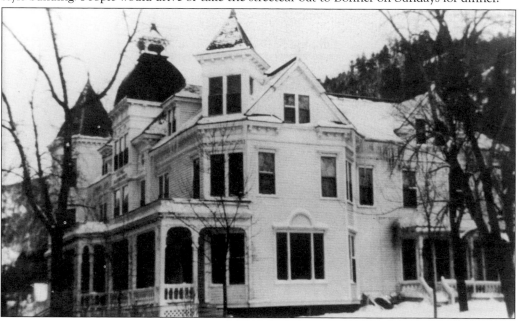

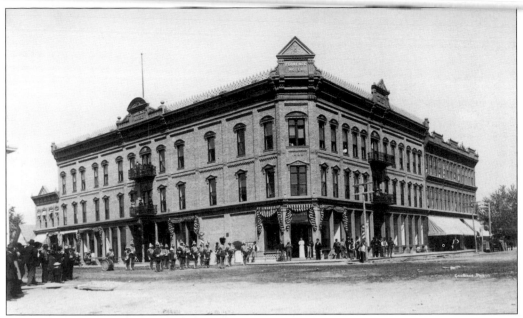

Missoula's first major hotel was built at the corner of West Front Street and Higgins Avenue in 1888. It was built by A.B. Hammond, who named it for his wife, Florence. A private electrical plant in the basement provided power for the building. Awnings were added a few years later, and a barber pole is on the street level. A military band is seen here on the Front Street side. (Courtesy of UM 84-305.)

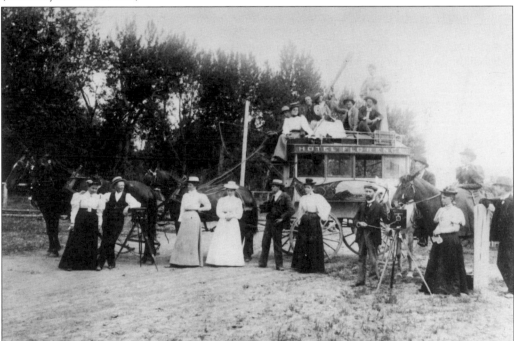

This interesting view is from the early 1900s, when the hotel had its own stagecoach to pick up train passengers and bring them to the hotel. Notice that there are two photographers—a third took this photograph. (Courtesy of the Historical Museum at Fort Missoula.)

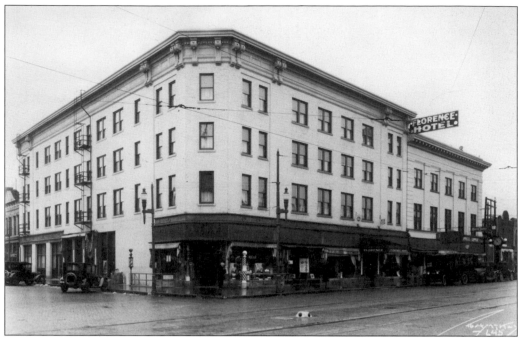

The original Florence Hotel burned down in 1913 and this less elegant building was constructed in its place. This photograph was taken in 1925 by Rollin H. "R.H." McKay, Missoula's most prolific photographer for many decades. Notice that the new hotel still had a barbershop. The Kohn Jewelry clock (far right) is still in approximately the same location.

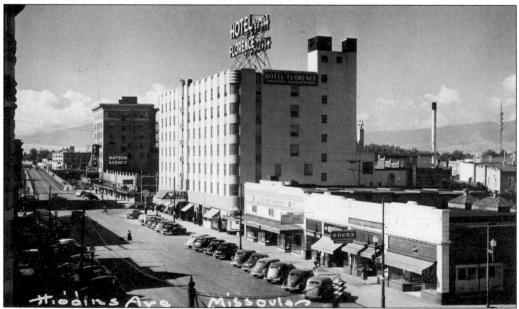

This postcard is dated 1946, five years after the third rebuild of the Florence Hotel. The new hotel cost $600,000 in 1941 and had 175 rooms, a main dining room, a coffeeshop, a cocktail lounge, banquet rooms, and several retail outlets. The Missoula Real Estate Association owned the Florence with money put in by many prominent Missoula businessmen. For decades, the Florence Hotel was the social center of Missoula.

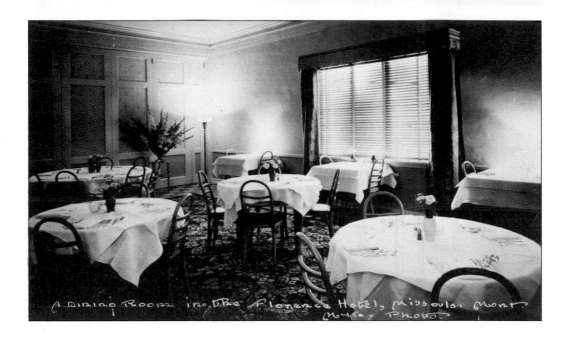

A Dining Room in the Florence Hotel, Missoula Mont.
McKay Photo.

A dining room in the Florence Hotel is seen above, with the lobby below. The hotel advertised itself as "America's Finest Small Hotel." The architecture is Art Deco and Art Moderne, and the building still dominates the downtown area. The downtown hotel business declined through the years, and the building was turned into office space in 1975. The lobby, however, was recently restored to almost its original appearance.

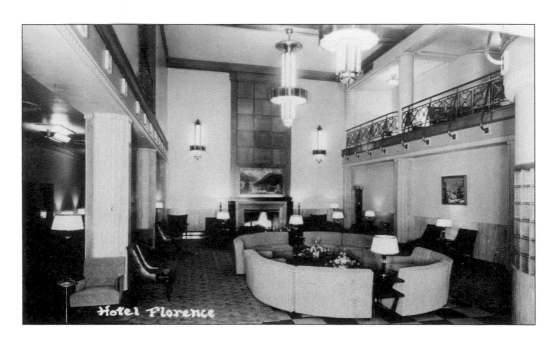

Hotel Florence

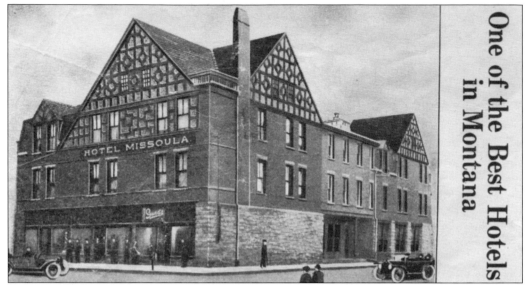

This imposing building at the corner of Main and Ryman Streets, the Missoula Hotel, was built in 1890–1891. One of the oldest buildings in downtown Missoula, it was originally built in the Tudor Revival style. Samuel Mitchell and Missoula mayor William Kennedy owned the hotel. It was also a railroad hotel, as the Northern Pacific Railroad used it as its operation center for the branch line to Idaho. In the 1950s, the hotel was converted to apartments, a few retail operations, and a bar on street level in the back section. In the basement were the Cafe Montmartre and the Jungle Room. The elegant café closed in the 1950s, but the bar stayed opened for years. The building changed hands in 1971.

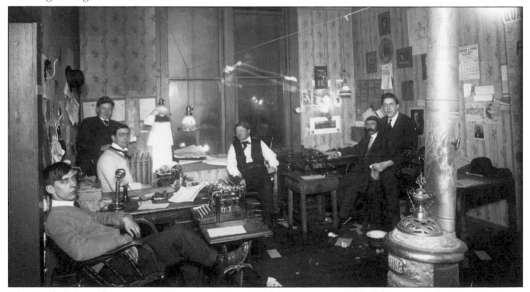

The *Daily Missoulian* news office was in cramped quarters in 1909. The original newspaper was established in 1870 in Superior, Montana. The name was changed to the *Missoula Pioneer* in 1871, then to the *Pioneer* later that same year. It was called the *Montana Pioneer* and the *Weekly Missoulian* before it finally became the *Missoulian* in 1873. It became a daily in 1891. It went through several owners but was eventually owned by the Anaconda Copper Mining Company until 1959, when Lee Enterprises bought it.

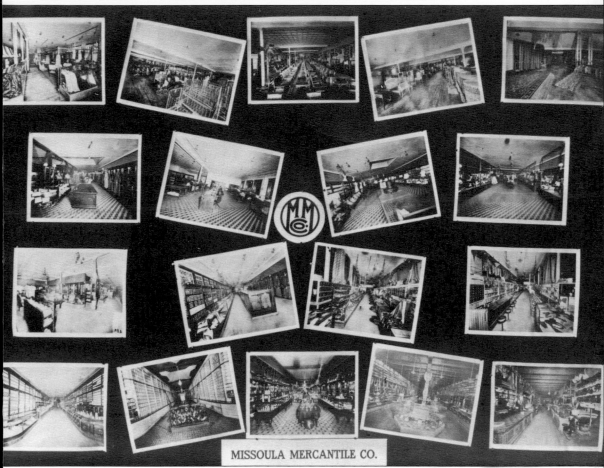

MISSOULA MERCANTILE CO.

This collage includes photographs of different departments of the Missoula Mercantile. The store sold just about everything, including groceries, hardware, furniture, buggies, and clothing. It even had its own delivery truck, as there were branches in Kalispell, Darby, Butte, and Hope, Idaho. The name lasted for years until it was sold to the Bon Marche and later to Macy's. The famous old store finally succumbed to malls and box stores and closed in 2010. A Virginia firm bought the building and is restoring it to its 1930s look and leasing out space for retail stores, offices, and restaurants.

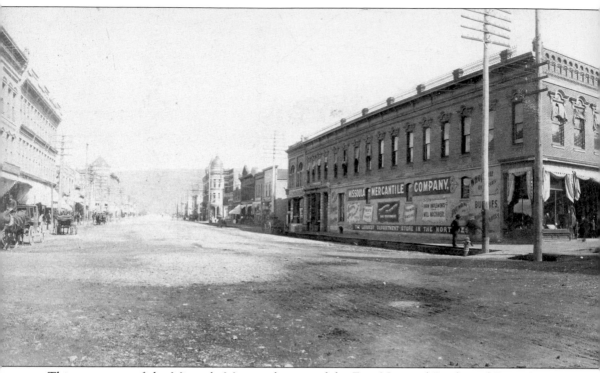

This panorama of the Missoula Mercantile, part of the First National Bank, and Front Street and Higgins Avenue was taken about 1904. The streets were dirt and the sidewalks were made of wood. The storefront windows on the Mercantile's Higgins Avenue street level were not in at the time. The store was the most important department store in western Montana. The first

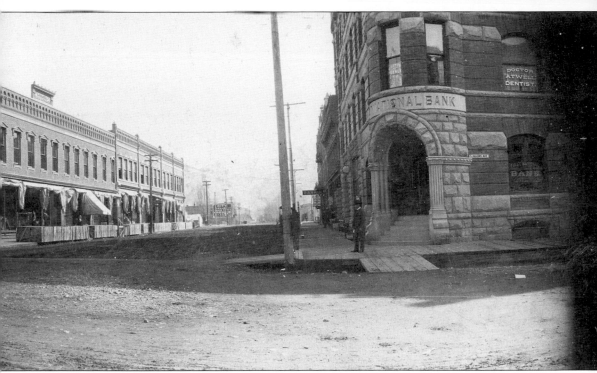

part of the building on the corner was constructed in 1877, and the entire building dates from 1904. The name Missoula Mercantile dates from 1885, with the consolidation of the previous Bonner, Eddy & Welch, and the later E.L. Bonner and Company. A.B. Hammond joined the company in 1876.

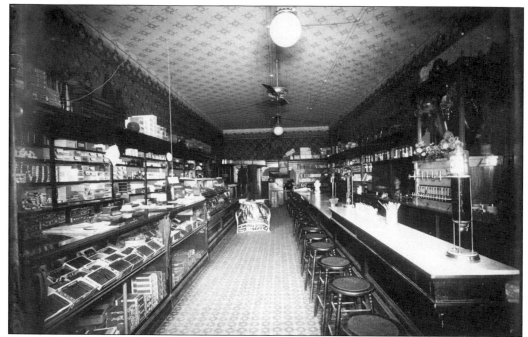

Hartley's Confectionery was in the Florence Hotel when this photograph was taken in 1898. The array of cigars (left) and the soda fountain (right) were both staples of this type of business at the time. Notice the play poster in the middle on the floor for September 27, 1898. It is assumed that this business was destroyed when the Florence burned down in 1913. (Courtesy of UM: 75-374.)

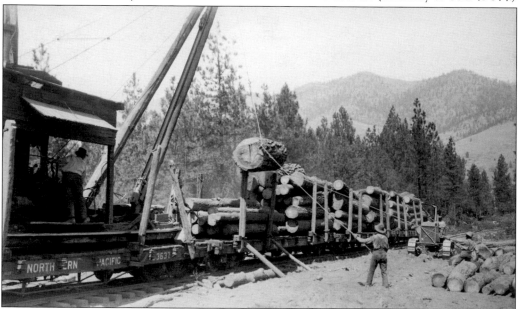

This is a typical scene of the former main industry in western Montana: timber. This photograph was taken in the Rattlesnake area, date unknown. Logging took place all over the area to feed the numerous sawmills in Missoula and the surrounding area. Most of the mills closed in the last quarter of the 1900s due to economic conditions. All of the large mills in the Missoula area are now closed.

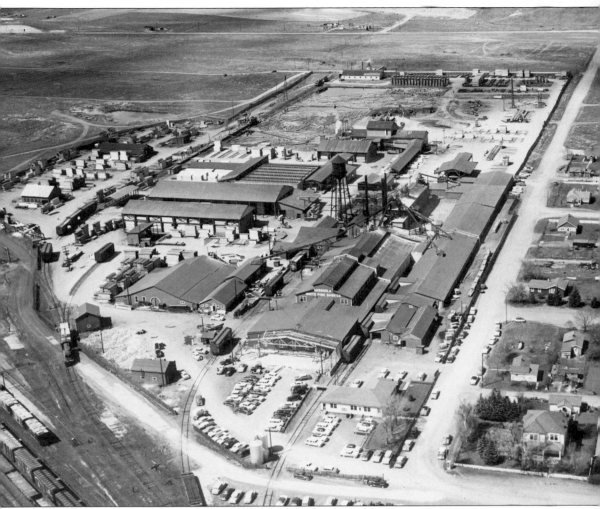

The White Pine Sash and Door Company on Missoula's north side operated as a sawmill and window and door manufacturer from approximately 1920 to 1996. For 50 years, a toxic chemical was used to treat the wood products. In 1994, the site was listed as a state Superfund site, and cleanup began. The mill was demolished, and businesses and the city shops now occupy the site. This is a 1962 view. (UM 94-3047.)

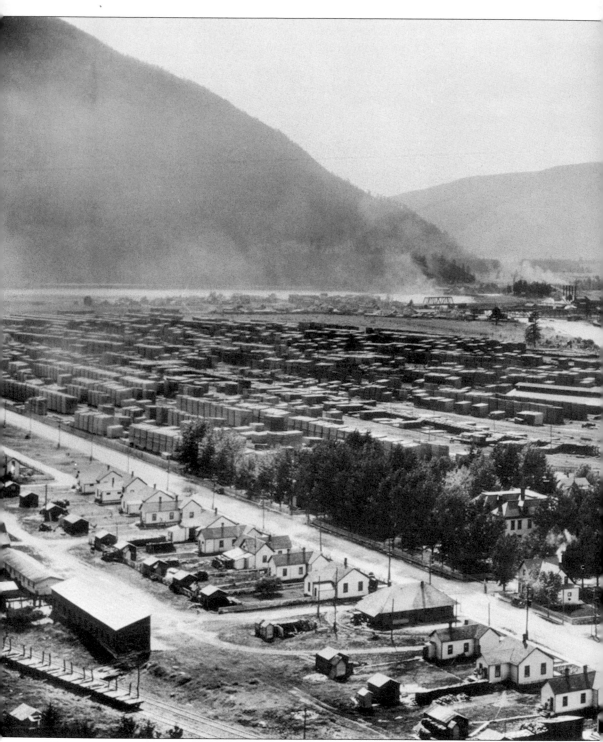

This great panoramic view of most of the Bonner operation shows the Anaconda Copper Mining Company lumber operation. The Western Lumber Company mill is in the background next to the river. The mill was sold to Champion Wood Products and finally to Stimson Lumber Company

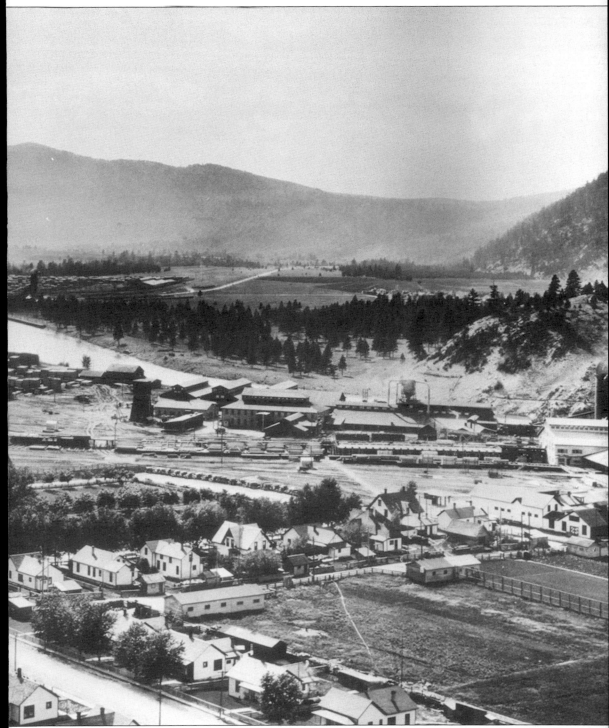

in 1994. It closed in 2008. It was one of the largest mills in the west and had the largest plywood plant in the nation. The site is now being redeveloped for timber and other industrial uses.

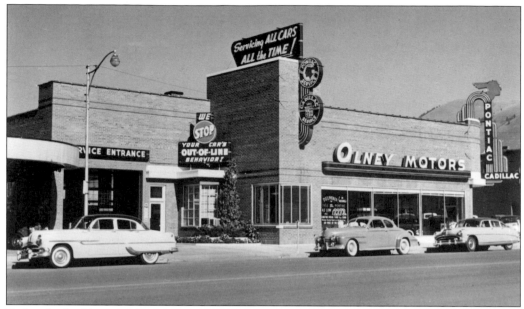

Today, this building, at 300 West Main Street, is occupied by Zip Auto Service, a private automobile repair shop. The original Zip Auto was across the street at 211 West Main. This building was constructed in 1947. At one time, Marcus Daly III was associated with Daly Motors, the Pontiac dealer in this building. Olney Motors eventually handled both Pontiac and Cadillac automobiles. Names, owners, and brands changed through the years, and the building was bought by Richard Nash in 1995. (Courtesy of MHS: 949-346.)

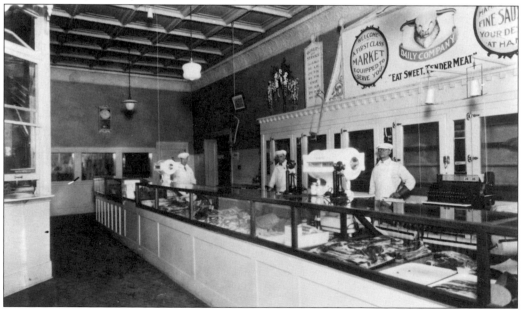

The John R. Daily Company, Inc., was founded in 1893 and became a major meat-processing business soon afterwards. He had several partners but became the sole owner in 1899. For years, his retail outlet was on the first block of West Main Street. The slaughterhouse was on Mullan Road. The Main Street store was sold in 1968 and the business moved to its Mullan Road property and became a major bacon producer.

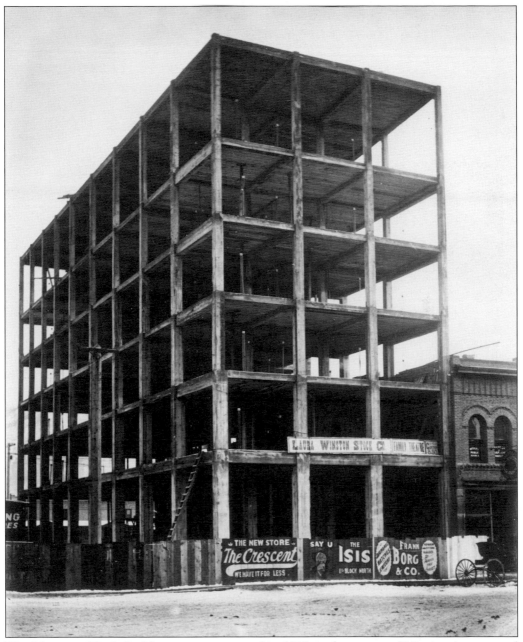

The Montana Block Building was constructed in 1909 at the corner of Higgins Avenue and Broadway for the Western Montana National Bank. It is now called the Montana Building and its facade has changed through the years. In 1910, Western Montana National Bank moved in from its location one block south. The well-constructed building was the tallest building in the downtown area until the Wilma Theater was built in 1921.

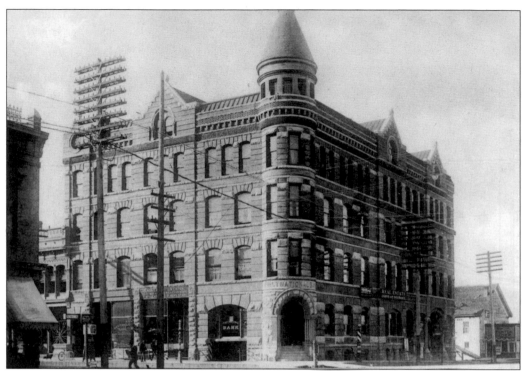

The oldest bank in Montana, First National Bank, was founded in 1873 and built in 1889 at the corner of Higgins Avenue and Front Street. At one time, the YMCA, Western Union, and well-known photographers R.H. McKay and F.M. Ingalls were based in the building. A.B. Hammond was the bank's first president. The building was out of fashion by the early 1960s and replaced in 1963. It was replaced again in 2011 by a much larger building.

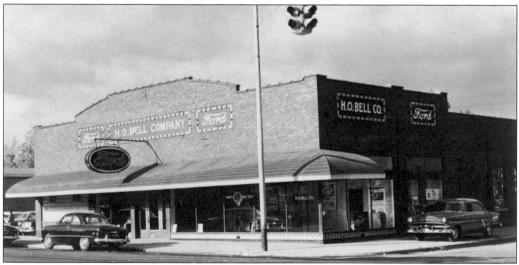

H.O. Bell came to Missoula in 1915 to take over the Ford dealership from Floyd Logan. He got a $60,000 loan to buy the new business. In 1929, he opened this showroom at the corner of South Higgins Avenue and Fourth Street. He was very active in the area's civic organizations, especially in aviation. He died in 1971, and the building was eventually torn down for a gas station. (Courtesy of MHS: 949-345.)

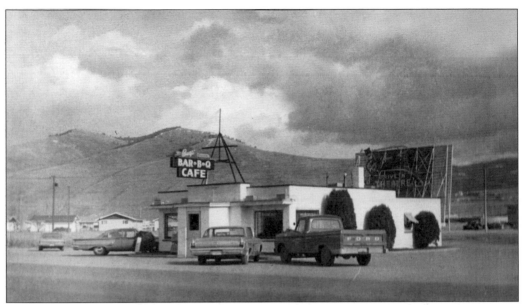

Bugs' Bar-B-Q was the earliest restaurant on Highway 93 South. At the time it opened in 1946, it was way out of town. It was started by Lawrence and Elaine "Bugs" Dwyer, thus the name. The restaurant was well known for its pies, which were baked by Babe Bogard. By the time it closed in 1974, the city had grown out to and past the restaurant. The State Drive-In Theatre is in the background. (Courtesy of Mike Dwyer.)

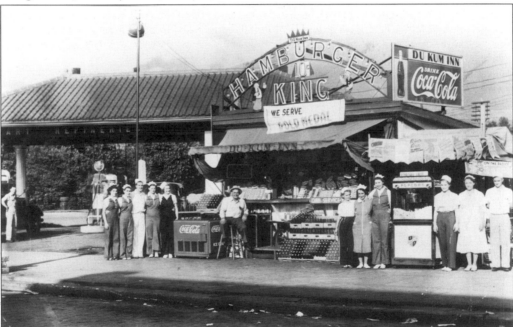

This interesting photograph of the Hamburger King or the Du Kum Inn, was at the corner of North Higgins Avenue, opposite the Northern Pacific depot. A Hart Refineries gas station is in the background, which is now the headquarters of the United Way of Missoula County. The King was a two-wheel trailer/booth that was opened 24 hours a day, seven days a week. It was opened in the 1920s. This photograph was taken around 1939.

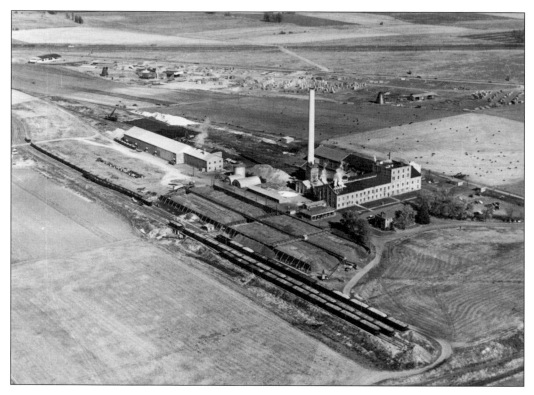

The American Crystal Sugar Company established this large sugar beet factory just west of Missoula in 1928. Sugar beets were a large crop for farmers all over western Montana. They were brought here and processed into granular sugar until the operation ceased in the late 1960s. One building still stands just off Reserve Street, and the city has grown out to the area. (Courtesy of MHS: 949-495.)

BUY
MISSOULA

THE *ONLY* SUGAR
✦ *Made in the* ✦
WESTERN HALF OF MONTANA

Ten

PEOPLE, PLACES, AND THINGS

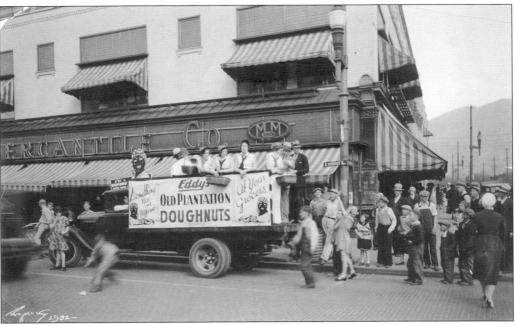

This interesting photograph was taken in 1932 at the corner of Higgins Avenue and Main Street. The sign on the truck is promoting Eddys Old Plantation Doughnuts. The bakery was started by James and Frank O'Connell in Missoula in 1908. By the time the bakery closed, more than 50 years later, there were 20 bakery outlets throughout Montana and the Northwest. Their bakery building just off South Higgins Avenue is now home to the eclectic shop Rockin' Rudy's. Missoula Mercantile, in the background, was the main department store in Missoula for many years but closed several years ago. It is being restored to its historical look from the 1930s to house a variety of businesses. It is not known for what occasion this photograph was taken. (Courtesy of Steve Bixby.)

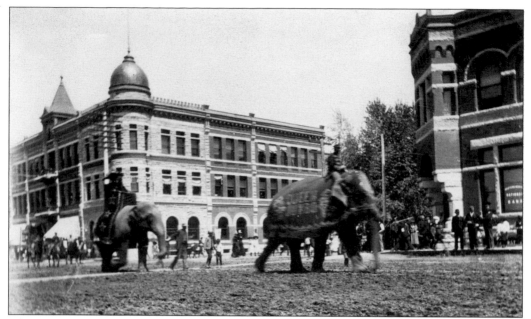

Like many towns of its size, Missoula usually had a circus come to town at least once a year. In early days, it was always celebrated with a parade through town. This photograph was taken in 1902 with the elephant Queen Jumbo leading the way. Notice the dirt, and often muddy, Higgins Avenue. The circus performed at several sites around town, including on the north side.

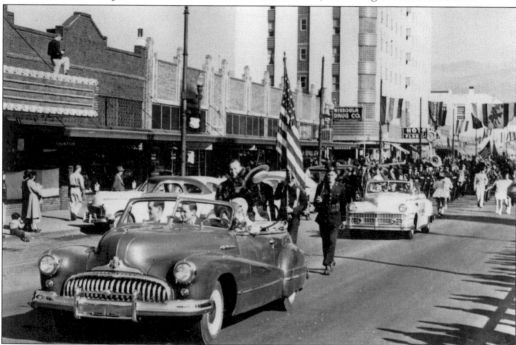

This view looks south at the 1948 homecoming parade on Higgins Avenue. This was and still is the biggest parade of the year, now taking place in September or October. Hammond Arcade is to the left and the marquee of the Wilma Theater is at the extreme left. The Florence Hotel is the large building in the background. (Courtesy of UM.)

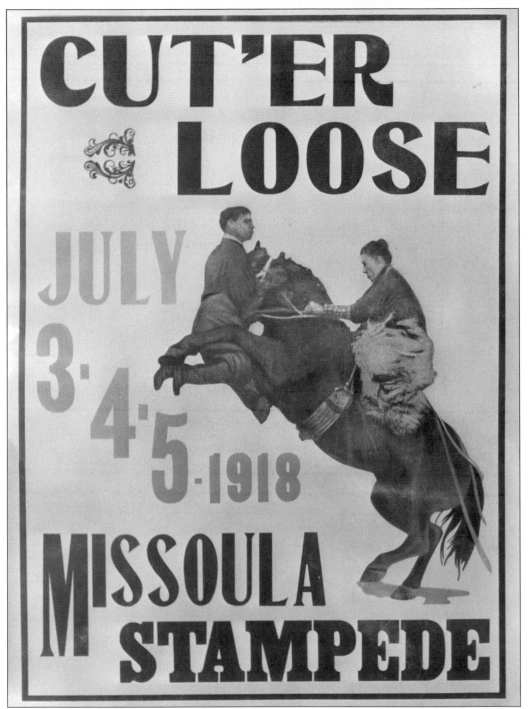

The Missoula Stampede was held for several years, usually around the Fourth of July. It apparently started in 1914 at the old fairgrounds and was held in 1915, 1916, and 1918. No stampede was held in 1917 because of World War I. Many events were held, including horse races, concerts, Indian dances, boxing matches, and rifle tournaments. A frontier town was also built. A parade was usually held, and the new, current fairgrounds were used starting in 1915.

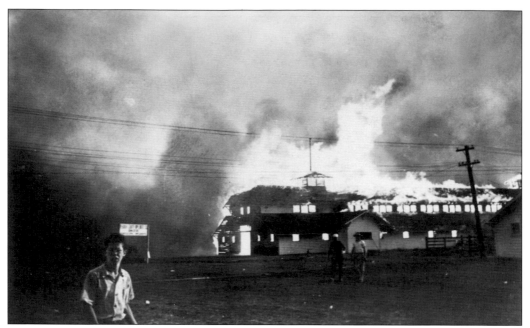

On the evening of August 21, 1941, a fire broke out in the east end of the fair's grandstand area, where 3,000 people were sitting. Everyone escaped without injury, but the grandstand, three large buildings, the main livestock barn, the 4-H club buildings, Indian teepees, cars, and equipment were lost, at a cost exceeding $120,000. After the fire, the fair did go on, even as carpenters on an airport project and all county equipment was moved onto the grounds to clear away debris and erect temporary bleachers. The fire was a devastating blow to the fair. It rained on Saturday so the abated fair was extended one day. A combination of the fire and America's entry into World War II marked the end of the fair, and it took 13 years for it to open again.

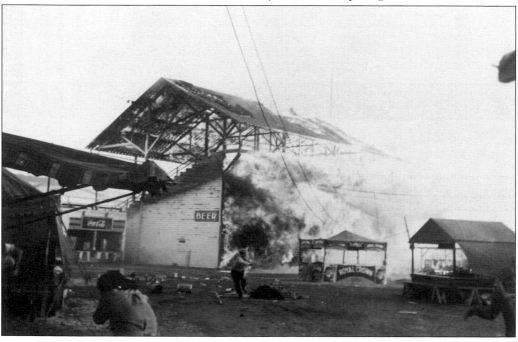

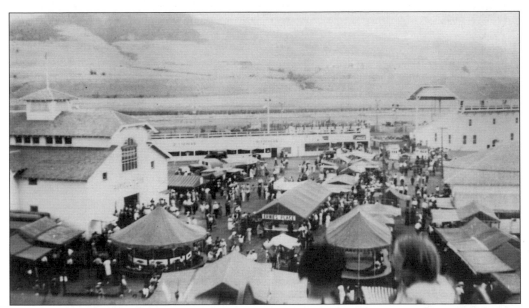

This view of the Western Montana Fair was taken in 1936 and shows the 1915 Agriculture Building on the extreme left, which is still in use but is now called the Commercial Building. The grandstand on the far right in the background burned down with other buildings in the vicinity in the 1941 fire. The carnival rides intruded into the space that is now used for food venders. (Courtesy of Bridget Wanderer.)

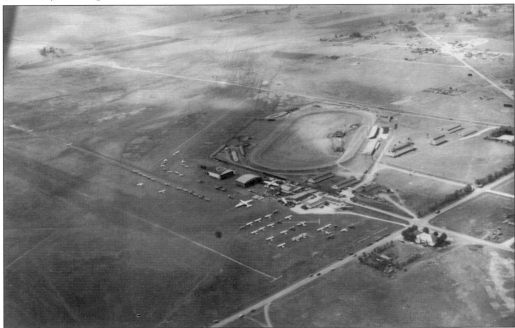

An aerial view of the fairgrounds and the adjacent Hale Field is seen here in the 1950s. The building on the lower right was the Casa Loma Night Club and is still standing. Hale Field closed in 1954 to make room for Sentinel High School and the Missoula Vocational and Technical School. Many Johnson Flying Service aircraft are in the field. Many new buildings have been constructed on the fairgrounds since it reopened in 1954.

On January 20, 1952, the movie *Red Skies of Montana* held its world premiere in Missoula. It was the first movie made about smokejumpers and was filmed in downtown Missoula and at Hale Field, Camp Menard, and Lolo Hot Springs. It was loosely based on the 1949 smokejumper tragedy out of Helena. It starred Richard Widmark, Richard Boone, Jeffery Hunter, Richard Crenna, and Constance Smith.

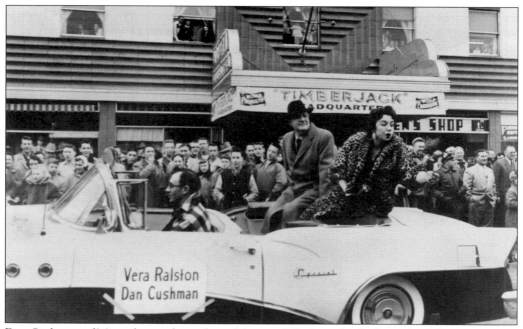

Dan Cushman of Missoula was the author of the novel *Timberjack*, which inspired the script for the 1955 film of the same name. It was filmed in the Blackfoot Valley and in Polson. Vera Ralston was the female lead in the movie, which was produced by Republic Pictures. Ralston was the national figure skating champion of Czechoslovakia before World War II and escaped from Europe in 1940. She appeared in scores of mainly "B" movies. Other actors included Sterling Hayden, Brian Keith, Adolphe Menjou, Hoagy Carmichael, and Chill Wills. Seen here is the parade in Missoula for the world premiere on February 4, 1955, with the Florence Hotel in the background.

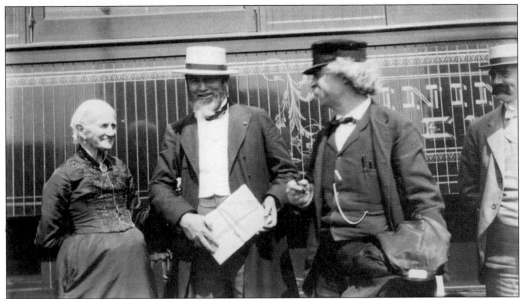

Famous author Samuel L. Clemens, known as Mark Twain, visited the Northern Pacific depot in Missoula. He was with Wilbur F. Sanders, one of the state's early pioneers and a senator from the state. They had met Eunice White Beecher, the widow of well-known clergyman Henry Ward Beecher, in Helena, and together they had traveled to Missoula on August 5, 1895. Twain was making a global tour in 1895–1896 to repair the financial problems of his two principal business ventures: a publishing firm and a typesetting machine, which had bankrupted him by January 1895. Twain had agreed to a demanding lecture tour to pay his creditors. Below, Twain is seen with Lt. Col. Andrew Burt, the commander of Fort Missoula. Maj. James B. Pond was hired to photograph and write about the July–August 1895 trip and to publish a book. It was published in 1895 with many rare photographs of the trip and was reprinted in 1992. (Both courtesy of Kevin MacDonnell and Elmira College.)

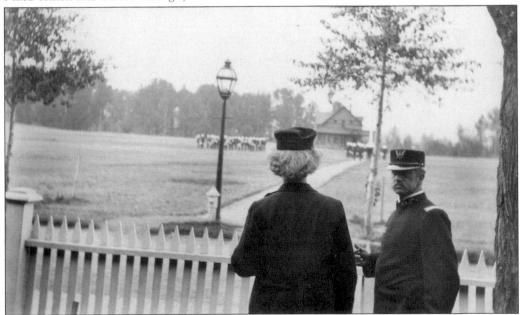

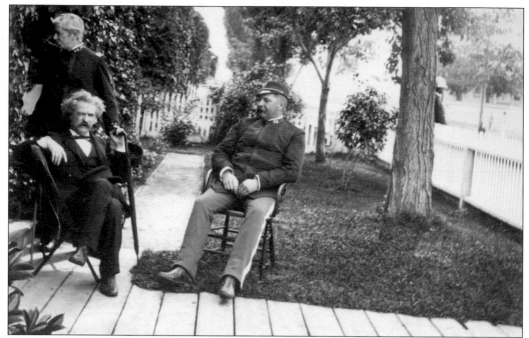

Twain is seen here relaxing at Fort Missoula. Officers from the fort had driven into town with an ambulance to offer to drive Twain's entire party out to the fort on August 6. Twain decided to walk the four miles to the fort instead, but he got lost on the way. Luckily for him, an ambulance spotted him walking, picked him up, and took him to the fort. He was very tired from his wanderings. (Courtesy of Kevin MacDonnell and Elmira College.)

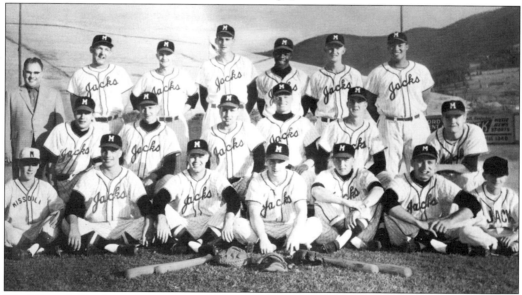

The Missoula Timberjacks represented Missoula in the Pioneer League from 1956 to 1960. Their best season was 1958, when they went 70-59 under manager Jack McKeon, who went on to manage several major league teams, including the 2003 World Series champion Florida Marlins. Country music star Charlie Pride played briefly for the team in 1960. Today, the Missoula Osprey represents Missoula in the Pioneer League. (Courtesy of Joe Dugal.)

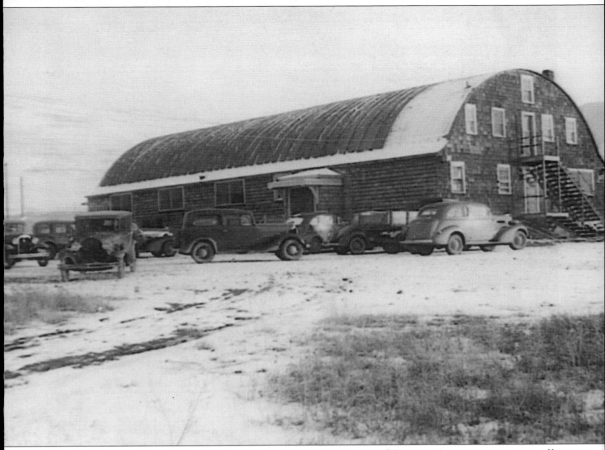

This building on South Higgins Avenue between Fairview and Benton Avenues was originally called the Avalon Club and eventually became a roller-skating rink. This view appears to be from the 1930s; the rink lasted into the 1960s. Today, there are ice-skating rinks at the fairgrounds to take the place of roller-skating. (Courtesy of Carol Crowther.)

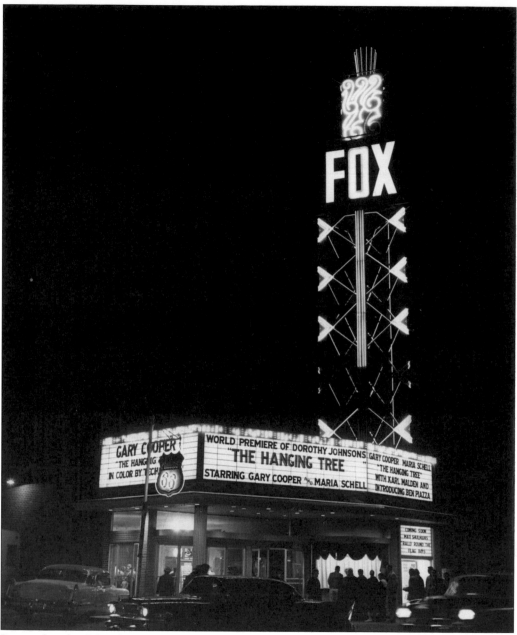

Pictured is the Fox Theater in 1959. It opened on December 8, 1949, at the corner of Orange and Main Streets with the movie *Everyone Does It*. It was a deluxe theater with a Robert Morton theater organ. It was operated by Fox Intermountain Theaters until 1973, then Mann Theaters until its closing in 1984. The site is now a parking lot owned by the city and is waiting for a major development. The movie *The Hanging Tree* was written by Dorothy Johnson, a resident of Missoula, and it starred Gary Cooper, a native of Helena, Montana. (UM 010119.)

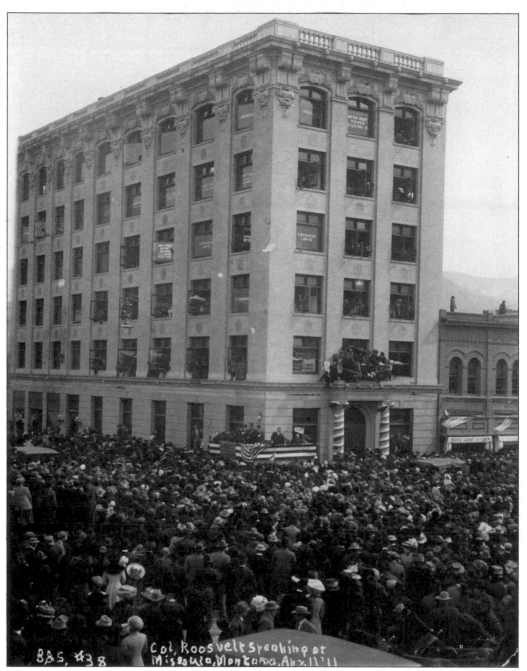

Col. Roosevelt speaking at
Missoula, Montana, Apr. 11 '11

8.2.5, #38

Theodore Roosevelt made his first visit to Missoula in 1886 to meet with the Montana Grocers Association. On April 11, 1911, former president Roosevelt visited the city again while on an extended speaking tour of the west. In the afternoon, he spoke to a large gathering at Western Montana Bank. In the evening, he attended a banquet at the Florence Hotel. On September 8, 1912, he again returned to Missoula, this time for 20 minutes, speaking from the back of a railroad passenger car in front of the Northern Pacific Railroad roundhouse. He was running for president under the progressive Bull Moose Party. He was defeated in the election by Democratic candidate Woodrow Wilson.

Jeanette Rankin was born and raised in Missoula, the daughter of John Rankin, a prominent resident of Missoula. She taught grade school for a time in the Grant Creek area and graduated from the University of Montana. She was the first woman to be elected to Congress in 1916 but was voted out of office after voting against America's entry into World War I. She was again elected to Congress in 1940 and was the only congressperson to vote against America's entry into World War II. She was then voted out of office after one term for the second time. She spent the next 30 years lobbying for pacifism and women's rights, right up to the Vietnam War. She died in 1973 at age 92. (Courtesy of MHS: PAC 90-23.)

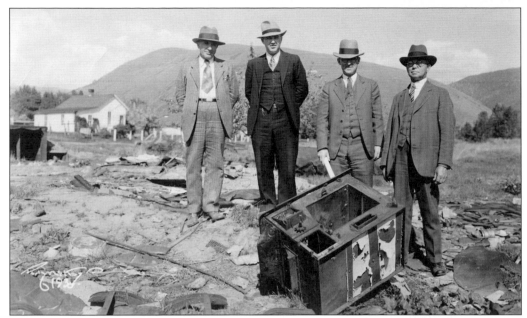

Kiwanis Park, a downtown park, was purchased by the civic club from the Missoula Mercantile in the 1930s. It had been used as a refuse dump and was acquired by the club to develop as a park. The property, on Lavasseur Street, was deeded to the city in 1942. This photograph shows the debris the park developers had to contend with. From left to right are Bob Richardson, Del McGuire, Reuben Coy, and John Patterson. The first Kiwanis Club in Missoula was established in 1914; today, there are three. (Courtesy of John Rimel.)

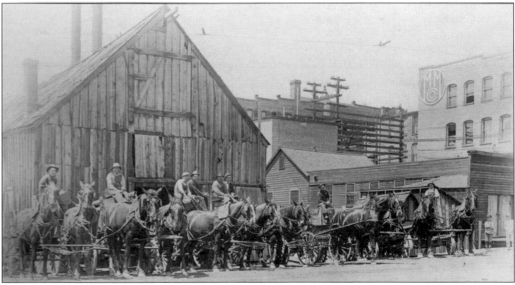

This previously unpublished photograph is from the early 1900s and barely shows the very top of the corner of First National Bank in the background. The smokestacks and power grids and buildings in the middle are part of the downtown power system. It is thought that the three-story building on the right with the MMC sign is the back of the Union Block, which is now the Radio Central Building. The arched wooden building with the horses in front is either the city livery stable or the hack stable. (Courtesy of Donna Hart.)

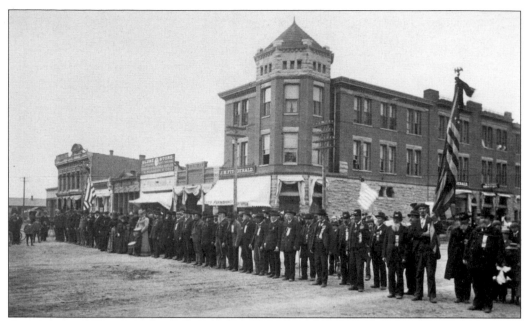

A gathering of Grand Army of the Republic (GAR) Civil War veterans lined up in front of the Daly Block or the Donohue Building on their eighth annual reunion in the 1890s. The GAR was a society of men who fought for the North in the Civil War and was founded in 1866. The organization had a strong nationwide membership in all the states, but the last member died in 1955, and the organization disbanded the next year.

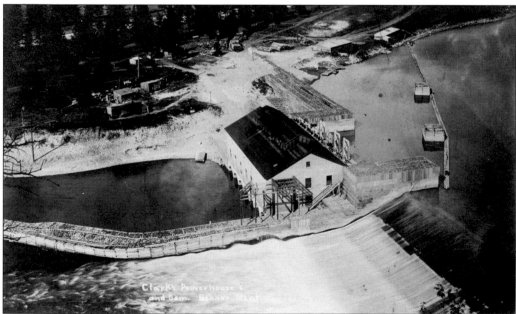

The Milltown Dam and the powerhouse were built by the Missoula Light and Water Company in 1908. William A. Clark, one of the "Butte Copper Kings" controlled the company, which supplied power for his Western Lumber Company and for all of Missoula. During the 1908 flood, the dam held but overflowed. In 2008, the entire complex was removed, letting the Blackfoot and Clark Fork Rivers flow freely for the first time in more than 100 years.

The Snow Park, or TV Mountain Ski Area, 13 miles northwest of Missoula, was started in 1954 with three rope tows. A Poma lift was opened in 1957 with a vertical rise of 750 feet. Because of its location and terrain, the area was moved to an adjacent bowl area in 1961 and named the Missoula Snowbowl. The area was started by local businessmen Dave Flaccus and Bob Johnson. The Snowbowl is seen here in 1965. The large lodge was built in 1961 and the two other buildings burned down and have been replaced. The area went through a few owners until it was bought by the Morris family, the current owners. They have done considerable work, adding a second chairlift, snowmaking equipment, on-site housing, and a bar. Snowbowl has a 2,600-foot vertical drop and good constant skiing for the local population.

BIBLIOGRAPHY

Benedetii, Umberto. *Italian Boys at Fort Missoula, 1941–1943*. Missoula, MT: Pictorial Histories Publishing Company, 1991.

Cohen, Stan. *Missoula County Images Vol. 1*. Missoula, MT: Pictorial Histories Publishing Company, 1983.

———. *Missoula County Images Vol. 2*. Missoula, MT: Pictorial Histories Publishing Company, 1993.

———. *A Pictorial History of Smokejumping*. Missoula, MT: Pictorial Histories Publishing Company, 1983.

———. *The University of Montana: A Pictorial History*. Missoula, MT: Pictorial Histories Publishing Company, 2004.

———. *The Western Montana Fair: A Pictorial History*. Missoula, MT: Pictorial Histories Publishing Company, 2995.

———. Postcard History Series: *Missoula*. Charleston, SC: Arcadia Publishing, 2004.

Koelbel, Lenora. *Missoula The Way It Was: A Portrait of an Early Western Town*. Missoula, MT: Gateway Printing, 1972.

Maechling, Philip and Stan Cohen. Then & Now: *Missoula*. Charleston, SC: Arcadia Publishing, 2010.

Mathews, Allan. *Montana Main Streets, Volume 6: A Guide to Historic Missoula*. Helena, MT: Montana Historical Society Press, 2002.

Smith, Minie. *The Missoula Mercantile: The Store that Ran an Empire*. Charleston, SC: The History Press, 2012.

Smith, Steve. *Fly The Biggest Piece Back*. Missoula, MT: Mountain Press Publishing Company, 1979.

Toole, John. *Red Ribbons: A Story of Missoula and Its Newspaper*. Missoula, MT: *The Missoulian*, 1989.

Van Valkenburg, Carol. *An Alien Place: The Fort Missoula Detention Camp, 1941–1944*. Missoula, MT: Pictorial Histories Publishing Company, 1995.

PRESERVE HISTORIC MISSOULA

One of the most important factors in furthering the practice of historic preservation is helping people appreciate the beauty and significance of the historically built environment and its context in specific areas. Stan Cohen's latest book, Images of America: *Missoula*, helps both residents and former residents of the Missoula area appreciate how our past influences our present. The book also provides valuable insights to visitors to the area, and to those who hope to visit in the future. Preserve Historic Missoula is pleased to participate in the book's production.

Preserve Historic Missoula is a private, nonprofit organization formed in 2006 with a bequest left by Dorothy Ogg, a longtime Missoula resident, businesswoman, and member of the Missoula Historic Preservation Commission. The group's principle mission is to provide the citizens of Missoula and western Montana with information, assistance, and activities that further the appreciation of the educational, historical, architectural, scientific, and aesthetic significance of their heritage. That heritage includes buildings, structures, objects, districts, and prehistoric sites. Preserve Historic Missoula concentrates on outreach efforts, including grants for painting historic buildings and for erecting National Register of Historic Places signs. We participate in public efforts to further the cause of preservation, and we support private projects that exhibit respect for historic resources in our community, our county, and our region. We hold an annual public event featuring speakers, music, and informational activities.

This book will play an important part in our efforts to promote preservation in western Montana by helping readers learn more about the historic resources we have saved as well as those we have lost. We hope they will enjoy turning these pages and experiencing the history of Missoula.

—Suzanne Julin
Preserve Historic Missoula

DISCOVER THOUSANDS OF LOCAL HISTORY BOOKS
FEATURING MILLIONS OF VINTAGE IMAGES

Arcadia Publishing, the leading local history publisher in the United States, is committed to making history accessible and meaningful through publishing books that celebrate and preserve the heritage of America's people and places.

Find more books like this at
www.arcadiapublishing.com

Search for your hometown history, your old stomping grounds, and even your favorite sports team.

Consistent with our mission to preserve history on a local level, this book was printed in South Carolina on American-made paper and manufactured entirely in the United States. Products carrying the accredited Forest Stewardship Council (FSC) label are printed on 100 percent FSC-certified paper.

MADE IN THE USA